ARCADIA BRITANNICA

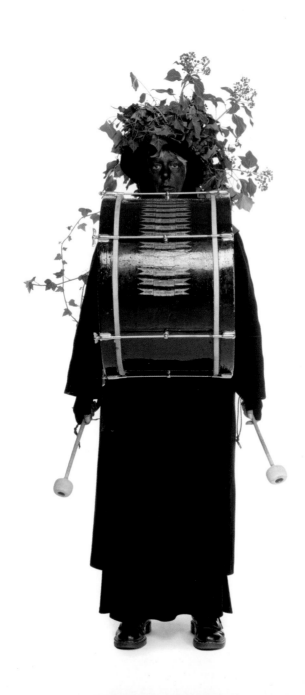

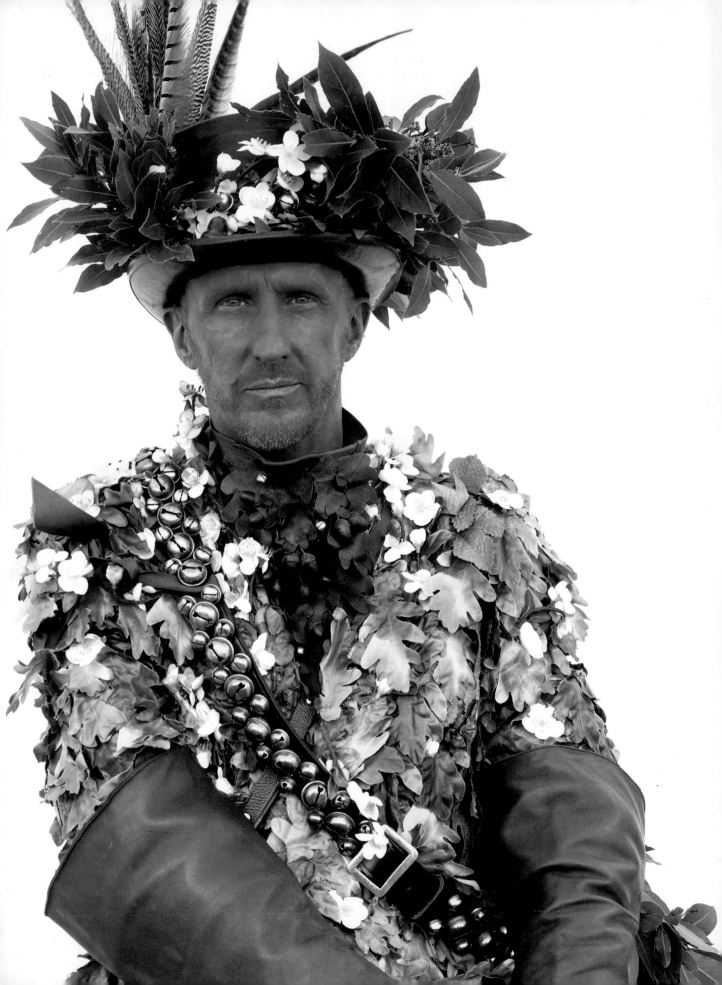

HENRY BOURNE

ARCADIA BRITANNICA

A Modern British Folklore Portrait

125 color photographs

Preface by **Robin Muir** Introduction by **Simon Costin**

Thames & Hudson

HENRY BOURNE is a photographer known for his portraits, architecture, landscape and still-life work. He is a regular contributor to *Vogue* and *Harper's Bazaar* magazines worldwide as well as to *T: The New York Times Style Magazine*. His editorial photographs have also featured in *Condé Nast Traveller*, *Wall Street Journal Magazine*, *Wallpaper** and *Vanity Fair* magazines, among others. His work has been exhibited internationally and forms part of the permanent collection of portrait photography at the National Portrait Gallery, London.

ROBIN MUIR is a writer, curator and former picture editor of *Vogue*.

SIMON COSTIN is the founder and director of the Museum of British Folklore and director of the Museum of Witchcraft and Magic at Boscastle, Cornwall.

Arcadia Britannica © 2015 Thames & Hudson Ltd, London
Text © 2015 Robin Muir and Simon Costin
Photographs © 2015 Henry Bourne

First published in 2015 in hardcover in the United States of America by Thames & Hudson Inc., 500 Fifth Avenue, New York, New York 10110

thamesandhudsonusa.com

Library of Congress Catalog Card Number 2014952409

ISBN 978-0-500-51797-0

Printed and bound in China by Toppan Leefung Printing Limited

On the cover, *FRONT*: Mr and Mrs Bob Humm, *Jack-in-the-Green*, Hastings, East Sussex; *BACK*: Rodger Molyneux, *Jack-in-the-Green*, Hastings, East Sussex

Page 1: Nicky Elliot, *OLD GLORY MOLLY*, *Whittlesea Straw Bear Festival*, Whittlesey, Cambridgeshire

Frontispiece: Craig Sheppard, *Jack-in-the-Green*, Hastings, East Sussex

Note: The photographs were taken at various folk festivals, events and rituals around the United Kingdom, which are identified where appropriate in the captions. The sitters provided either their actual name or a 'folk' name, and in certain cases their profession.

CONTENTS

Foreword
Robin Muir
6

Introduction: 21st Century Folk Culture
Simon Costin
9

THE PORTRAITS
14

A Calendar of British Folklore Events
188

Acknowledgments
192

FOREWORD
ROBIN MUIR

SIR BENJAMIN STONE, Member of Parliament, businessman and enthusiastic amateur photographer of the late Victorian and early Edwardian era, would think nothing of an all-night session in the House of Commons and then a day's journey in a quest to make pictures, as his biographer put it, 'of all kinds of curious customs and picturesque festivals, even those which occur only once or twice in a lifetime'.

For Henry Bourne, Stone's most recent successor, those meticulous prints remain the starting point for a serious inquiry into British folk tradition in photographs: from 'calendar customs' to cheese-rolling, hurling the silver ball, hare-pie scrambling and those institutions traceable back to a point in time, the Royal Maundy ceremony, for instance, or pancake tossing at Westminster School, which intrigued Stone enough to devote several pages of his *Records of National Life and History, Volume I: Festivals, Ceremonies and Customs* (1905) to each of them.

Of course, there were other gifted amateurs, often local, mostly anonymous and unsung; for who, after all, could not make in Hastings on May Day a lively representation of Jack-in-the-Green and his brightly coloured retinue? Or feel the mystery and, on the face of it, the discomfort of the Burry Man in South Queensferry? Or the pathos and drama of the Straw Bear's parade around Whittlesey 'to entertain by his frantic and clumsy gestures the good folk who had on the previous day subscribed to the rustics, a spread of beer, tobacco and beef', as one newspaper of 1889 reported it.

Stone was unprejudiced and open-minded, the supreme observer. 'Curious' is as far as he would venture in an opinion. Henry has allowed himself a few more words: 'What is fascinating here is the culture of dressing up, this "taking on" of another identity; it may be harking back to another era or maybe it's just pure fantasy but either way it's completely what we do, it's very British. Some of these traditions have completely changed, or have evolved into something else to the extent that no one, perhaps, is entirely sure of the origins or where it all might be going.' That, concludes Henry, matters little to many of those who take part, whose enjoyment flows from assuming the guise of another persona, if only for one day in the year.

Henry has made his own study of Sir Benjamin's work, initially thanks to his father, who was a professor of history, and subsequently at the Victoria & Albert Museum. Notwithstanding the obvious points of difference – Bourne's folk portraits are made in vivid colour against a neutral backdrop, Stone's resolute in monochrome and to a man (or a woman or a child on a wooden hobby horse) portrayed *in situ* – both photographers meet their subjects head-on, eyeball to eyeball, relishing the scrutiny that frontality brings. And, importantly for future scholars, Henry has suc-

ceeded at least as much as his Victorian precursor in the feat of preserving the magic of an ancient ritual and its accoutrements while allowing us to analyse the participants themselves, who cannot help but reveal in so many ways the personalities behind the camouflage. In Henry's contemporary document, is the Straw Bear wearing a wristwatch? Could that man (or sitter) at the Abbots Bromley Horn Dance ever hope to conceal his profession behind so slim an accordion? Do the Ordained Priestess of Isis's grey lace-ups not look contemporary to you?

'I wanted the formality that Stone brought to his record,' says Henry. 'I didn't want to photograph people at events in the reportage tradition; I wanted to concentrate fully on the individuals themselves rather than involve even the perimeter of the events at which they gather.' The white background of his portable daylight studio makes each portrait a happily democratic one, though the isolation of his sitters, if only for a few moments, lends the occasion a sense of gravitas.

Daylight and the neutral backdrop are not, Bourne concedes, an original idea. His antecedents are many: Irving Penn observed the inhabitants of Cuzco, high up in the Andes, in an old daylight studio with a plain grey backcloth, for the portraits that would make up, several decades later, *Worlds in a Small Room* (1974). For *In the American West* (1985), Richard Avedon's magisterial socio-anthropological despatch from the American hinterland, he carried with him rolls of white paper, nine feet by seven, to be fastened to the side of a barn or a trailer or, occasionally, just held up by willing hands.

'It's a good way of making sure it's about the participants,' explains Henry. 'With Simon [Costin, collaborator and instigator of the Museum of British Folklore] our first visit was to Jack-in-the-Green, Hastings, and I knew I wouldn't have a queue of people waiting, so I picked certain ones and realized pretty quickly that everyone likes to be photographed.'

Henry's project is on-going. Homer Sykes, the Canadian photographer who brought an outsider's eye to the depiction of British customs and culture that became *Once a Year: Some Traditional British Customs* (1977), made his odyssey around Britain a seven-year one. As Sykes discovered, there is something folkloric for each day of the year and one could, if feeling energetic, travel laterally to flower-strewing and 'swan upping' ceremonies or, say, view the street-sweeping that is part of the Worshipful Company of Vintners' procession to St James Garlickhythe in the City of London. Perhaps these are snapshots of society rather than relevant to folklore, but the rites and idiosyncrasies seem to chime.

If anyone feels that modern life has left these rituals stranded as irrelevant archaisms or cast them into reaches unfathomable to any but the most fanatical, he or she need only glance at the newspapers. In the week of writing this foreword, Prime Minister David Cameron was accused of racial offence by posing for photographs in his Oxfordshire constituency with a troupe of blacked-up morris dancers. Across the political divide, Will Straw, son of Labour politician Jack Straw and a prospective Parliamentary candidate himself, had previously done much the same at Bacup, Lancashire, with the artificially darkened Britannia Coco-nut Dancers. The 'Coco-nutters' had previously made the papers when their dance strayed into the road, earning disapproval from Lancashire County Council's Health and Safety Officer. At least they continued their dance on a more secure footing. When Andrew Taylor, the 2014 Burry Man, became the victim of his costume, as observed by the *Scotsman*, the main attraction of the Ferry Fair at South Queensferry

outside Edinburgh was absent for several hours. An irritant in his eye was removed by medics and presently the show rolled on. The Burry Man was phlegmatic: 'it did help that I could take a little sip of whisky throughout the day. That eased the pain.'

What was striking about the newspaper stories was, in the case of the Prime Minster and the morris men, not the sense of outrage, which was perhaps not surprising (although the blacked-up faces are probably a reference to chimney sweeps' sootened faces), but the sheer numbers attending the occasions, as revealed by the accompanying photographs. In answer to the question as to why these types of activity survive in modern times, especially when they serve no obvious purpose, the folklorist and social historian Peter James, in the book *A Record of England* (2007), points to the fact 'that a particular custom has survived for many years implies that for the participants at least, customs are important'.

It is an ancient thought and one that Stone would surely have articulated had he the anthropological interest to do so: that however visually surreal, however anachronistic, whatever the pleasure, peculiar or satisfying, a glimpse at folkloric tradition gives us, its very sameness echoes back through time with reassurance. Perhaps, to paraphrase Peter James again, it gratifies some physical and social need in the participants and the observers too. We are rooted helplessly to a past even our rapidly changing world cannot ever allow us to escape. How fitting it is to know that the antlers wielded by Sir Benjamin Stone's horn dancers of the late Victorian era are still those, preserved in the local church at Abbots Bromley and brought out annually and with great ceremony, that Henry portrays here – and the focus of rapt attention for many hundreds of years before that.

Henry has enjoyed a long career in photography, his commissions appearing in the better magazines the world over, including *Vogue*, through whose pages I first got to know of him. I have seen Henry at work and marvelled at the discipline, the rigour of composition, the effortless charm needed to coax an inexperienced sitter, and admired an eye that few could ever hope to emulate. It is entirely predictable – and satisfying – that in a riot of colour a sense of celebration and collaboration with his subjects marks out the portraits in this, his first book.

'We usually set up between Simon's caravan and maybe a vegan burger stand,' he reflects of those spring and summer days just gone. 'Always we get sightseers asking how much it is to have their picture taken.' Sometimes it is difficult for Henry, always sympathetic, to say no to a passer-by, but a line has to be drawn in the sand (or across the village green). We, his eager viewers, may come to regret it: 'There is always someone dressed up as a hot-dog or a giant yellow banana.' So much for a vanishing heritage. It all begins again.

Introduction
21ST CENTURY FOLK CULTURE
SIMON COSTIN

IF YOU WERE TO ASK a random sample of people in the UK what they understand by the word 'folklore', I suspect that the most common response would be 'morris dancing' or 'maypoles'. I doubt you would hear mention of the Abbots Bromley Horn Dance in Staffordshire or the Jack-in-the-Green procession in Hastings in East Sussex. Yet folk culture in Britain is very much alive and kicking. Perhaps the increasing uniformity in our towns and villages, as well as a world that is becoming ever more technological and impersonal, are factors spurring people to come together and celebrate long-established traditions whose origins are lost in the mists of time. And it should not be forgotten that the British have a distinguished record in fostering and valuing eccentricity, often to the bafflement of the rest of the world.

Various people have tried to define 'folklore'. In 2013, speaking in a short film in support of the Museum of British Folklore, the historian Ronald Hutton described folklore as 'the record of what people have believed' and as such 'it gives us a totally unique insight into the way in which people have felt, feared, loved, explored, speculated and thought in general'. In his essay 'On Postmodern Folklore' (1991), the American academic and folklorist Gerald E. Warshaver distinguished three 'levels' of folklore:

1. Customary practice, meaning customs where the participants would not consider themselves to be doing anything folkloric, such as hen/stag nights, weddings and funerals.

2. Traditional folklore practices, including morris dancing, folk singing, seasonal events, storytelling, and folk crafts such as corn-dolly making.

3. Contemporary 'invented' folk customs, for example those of the New Age movement or men's movement, which often use motifs from historic practices as a springboard for developing new events with a 'folkloric' feel. This category also includes folklore that has been consciously incorporated into video games, films, plays and performances.

Inevitably these 'levels' overlap and not everyone necessarily agrees with them, but I find them useful when trying to explain the diversity of folk practice. The photographs in this book fall mainly into Warshaver's second category. Once you understand that 'folklore' can cover a range of human experience, from the signs and symbols used by urban gangs to the use of bicycles painted white and chained to railings to mark the death of a cyclist, the word begins to convey more than the pastimes of a rural idyll re-imagined by the Victorians.

I first became intrigued by the rich variety of traditional customs when I was growing up and discovered on my parents' bookshelves a copy of *Folklore, Myths and Legends of Britain*, published in 1973 by Reader's Digest. It outlined many seasonal

events and recounted folk tales associated with particular regions, such as the witches of Pendle, the giants that roamed the Fens, and Herne the Hunter riding his black horse through Windsor forest. Thus began a fascination with folk culture and when we set off on a family holiday I would make a note of whatever customs the area we were going to was known for.

Over the years, my interest led me to realize that there was no specific place in the UK where you could learn about British folklore and traditions. Hilary Williams, then director of the Ditchling Museum of Art + Craft in Sussex, encouraged me to take the idea for such a museum out into the world to see if there was interest in it from a wider audience. I purchased a 1976 Castleton 'Roberta' caravan – there is nothing more folkloric than a caravan – and, using my skills as a set designer, converted it into a mini travelling museum. In the spring of 2009, after a successful fundraising event and launch of the idea, I set out on a six-month journey visiting folk festivals around the country, from Dorset to the Scottish Highlands, from Shropshire to Norfolk. Hundreds of people squeezed through the caravan's doors and I was asked one question more than any other: 'Why is there no museum of folklore in Britain?' I am now correcting this state of affairs with the Museum of British Folklore, for which I hope to find a permanent home in due course.

When I told my friend Henry Bourne of my museum plans he was intrigued and decided upon a portraiture project to document some of the extraordinary personalities attending the events. I would often accompany him and enjoyed experiencing the controlled chaos characteristic of these occasions, while Henry would remain calmly at work under canvas with his camera. He started in Hastings recording people taking part in the Jack-in-the-Green festival.

Stretching back almost three hundred years, this parade, which is not unique to Hastings, has its origins in the celebration of May Day, the start of summer, which itself was marked by the Celts and the Romans. The latter dedicated the day to the goddess Flora and decorated a tree with ribbons and flowers.

According to contemporary descriptions, in England in the early 18th century milkmaids carried garlands and danced in the streets on May morning collecting money. As the tradition evolved, the chimney sweeps, who were less busy during the summer months and in need of extra cash, joined in, dancing and playing rough music. At some point the garlands seem to have developed into elaborate headdresses, in particular a wickerwork frame covered in leaves that disguised the body of the dancer – the Jack-in-the-Green was born.

Always rowdy and often drunken, the event provoked rumblings of concern in the press throughout the 19th century. In 1888, the *South Bucks Free Press* observed that 'an occasional "Jack-in-the-Green" with his tawdry attendants parades the streets of provincial towns and villages and strives to tap the vein of copper that lies deep in the pockets of the benevolent, but he is a relic of old times stranded on a shore where he attracts little attention and less sympathy.' By the beginning of the 20th century Jack would sometimes appear at May Day charity events, but only as a reminder of a past custom.

In 1983, Keith Leech, a Hastings local and a member of the Mad Jacks Morris Dancers, studied records of the earlier processions and how Jack-in-the-Green had been celebrated in the town in the past. However, as the organizers of the present-day festival point out on their website, 'We do not say we are following exactly what happened, this is a custom for now, not a fossil.' It is a

lively and well-attended event spanning the May Day weekend, bringing in much-needed revenue to the small town and fostering local pride and community spirit. As well as people dressed as sweeps and milkmaids, the Jack is attended by Bogies with green painted faces and dressed in green tatter costumes strewn with foliage. Gay Bogies, particularly known for their lavish and extravagant finery, are among this retinue of followers, a sign of the event's healthy and inclusive nature. It is a good example of a folk tradition that has undergone change and mutation and become something relevant and vital for the present-day inhabitants of Hastings and those who come from all over to attend the festivities.

The wheel of the year features over seven hundred folklore events in the UK, for the most part linked to a specific season or date. Some six months after the May Day celebrations, Guy Fawkes Night (Bonfire Night) on 5 November marks the day in 1605 when a group of Catholics was foiled in its attempt to assassinate the Protestant King James I by blowing up the House of Lords and everyone in it. Lewes in East Sussex has the largest bonfire celebration in the country: seven bonfire societies mount parades through the town and carry huge effigies, not only of Guy Fawkes and Pope Paul V (pope in 1605), but also of contemporary figures considered 'Enemies of Bonfire', such as Vladimir Putin. The bonfire societies choose their own particular 'pioneer groups' to represent and these range from Vikings and Zulus to Native Americans and American Civil War soldiers. Members of these groups often attend the Hastings bonfire event, held a few weeks before the one in Lewes. Sometimes dates and celebrations become conflated. The Hastings bonfire night is held on or near to 14 October, the anniversary of the Battle of Hastings in 1066. Similarly, burning crosses are carried in the Lewes parades in memory of the seventeen Protestant martyrs burnt at the stake in the town in 1555–57 during the reign of Queen Mary.

Disguise and transformation play a large part in many seasonal customs. At Bacup in Lancashire the Britannia Coco-Nut Dancers process through the town on Easter Saturday performing a series of dances to music played by the Stacksteads Silver Band. The dancers' appearance is striking and its origins obscure. One theory is that Cornish tin miners brought the dances north when they came to work in the Lancashire coal mines in the 18th and 19th centuries and the blackened faces of the participants are linked to the faces of miners covered in coal dust. The blacking of faces is found in various folk traditions (e.g. mumming and Border Morris) and was an effective form of disguise when performers should have been working, not dancing and drinking. In other cases it can be traced back to the popular 19th-century minstrel tradition. The dancers' costumes are thought to be related to those of North African sailors who settled in Cornwall. Each dancer wears wooden discs or 'nuts' on his hands, knees and belt and during the two nut dances the discs are struck together in time with the music. These discs are said to relate to the wooden knee and elbow protectors worn by miners when crawling along a seam. On their way through Bacup the 'Nutters' also perform five garland dances and the men carry garlands decorated with red, white and blue 'flowers'. These spring ritual dances could be connected with the renewal of crops.

Plough Monday (the first Monday after Epiphany), the traditional start of the agricultural year in January, gave rise to its own traditions. In Cambridgeshire villages in the 19th century, on the Tuesday following Plough Monday, a straw bear led by a rope through the streets by a man holding a collection box 'danced' for gifts of food

or money. The bear, based on dancing bears, a popular form of entertainment in the past, was a man covered in straw to resemble a sheaf of corn. The custom faded away in the early 20th century but was revived in Whittlesey (historically Whittlesea) in 1980 and is now an important festival with a procession of Molly, morris, clog and sword dancers, musicians and mummers. The bear's costume is burnt the following day to make way for a new bear to be created the next year.

It is often thought that most traditions originated in the countryside, but towns can yield just as much folklore and it is sometimes surprisingly recent. London, for example, has its own much-loved Pearly Kings and Queens, who date from the late 19th century. In 1861, a man called Henry Croft was born at the St Pancras Workhouse in Somers Town, north London. He grew up to be a road sweeper and by the late 1870s he had begun to decorate his clothes with mother-of-pearl buttons that were mass-produced in the East End. Why he did this is not known, but possibly it was to attract attention when taking part in charitable pageants. He had both 'smother' suits, which were entirely covered with buttons, and 'skeleton' suits that had more of a pattern. By 1911 there was a Pearly King and Queen in every London borough and they formed their own association that year. The Pearlies are still actively involved in raising money for various charities and such is their connection with London that in 2012 a group of them featured in the opening ceremony of the Olympics held in the capital.

Some customs relate to dates in the religious calendar, such as Easter, harvest festival and Christmas. However, with church attendance in decline many of the events have disappeared or have lost some of their meaning. Now that virtually any kind of foodstuff can be obtained all-year-round, the harvest festival no longer has quite the

same significance it once did. Easter generated a whole range of customs – traditionally it is a greater festival than Christmas. Hot-cross buns were sold on Good Friday and at St Bartholomew-the-Great in Smithfield in London they are still distributed on that day, supposedly to widows. There used to be a belief that buns baked on Good Friday would not go mouldy in the year ahead.

In one form or another superstition and witchcraft have existed since time immemorial and stories of witches both benevolent and malign are pervasive across Britain. Historically, villages would have had their own cunning men or women who offered 'cures' for human ailments and remedies for sick livestock. They could also be appealed to for a love potion, as fortune tellers, or even to find lost property. Henry met and photographed several modern-day witches I know. Most striking is Maureen Wheeler, a priestess of Isis, dressed in her Egyptian-inspired robes. Paganism is on the rise in Britain – those who classify themselves as pagan doubled between the census of 2001 and the survey of 2011. Many pagans identify strongly with seasonal customs and events, some sensing a direct link with pre-Christian practices, despite the lack of written evidence.

The origin and meaning of customs are often obscure. South Queensferry on the Firth of Forth in Scotland can trace its annual Ferry Fair to a proclamation of 1687, but the Burry Man ritual that takes place on the eve of the fair in August has no such documentation. Covered from head to toe in a costume constructed from about 11,000 burrs (from which the name Burry Man might derive) taken from the thistle (burdock) plant, this figure spends the day processing through the town supported by two attendants and accepts glasses of whisky (through a straw) from locals he passes. The nature of his costume means he has to keep his arms raised (to prevent them stick-

ing to his sides) and he cannot sit down; it is also covered in insects. Only men born in the town can take on the role and they usually do it for several years. John Nicol, a graphic designer who is the Burry Man portrayed in this book, has described the mental and physical preparation needed for the role and how, at the end of the day, when the costume was stripped from him and the agony was over, he had a sense of being reborn.

Whether the Burry Man is a guardian to ward off evil, or a nature spirit like the Green Man, no one knows, but it is considered good luck to meet him, though you should not look him in the eye. Similar figures used to exist elsewhere, such as in the fishing communities of Buckie on the Moray Firth and Fraserburgh in Aberdeenshire; the Burry Man was paraded there when the weather was bad in order to help 'raise the herring'. A magical figure who can perform some kind of propitious magic is a potent idea and the Burry Man of South Queensferry certainly feels ancient and strange, whatever his origins.

Another old and unique custom survives at Abbots Bromley in Staffordshire's Forest of Needwood. Early in the morning of the Monday following the first Sunday after 4 September, a group of twelve curiously attired men meet at St Nicholas church in the village. Hanging in the church are six sets of reindeer antlers, each mounted on a carved wooden deer head on the end of a short pole. Three are painted off-white with dark tips and three are black with off-white tips; it is thought that historically the horns were painted with the arms of the local landowners. After a service of blessing six dancers take the antlers and accompanied by the Jester, Maid Marian, the Archer, the Hobby Horse, an accordion player and a young boy playing the triangle process and dance through the village. Their route takes them to Blithfield Hall where they perform on the lawn

– the dance itself is relatively simple as the antlers are heavy – coming back to Abbots Bromley in the afternoon. The group stops off at homes and farms for refreshments before returning the antlers to the church.

The horn dance is not recorded anywhere until Robert Plot's *Natural History of Staffordshire* of 1686, but there is mention of a hobby horse in Abbots Bromley in 1532. The custom has waxed and waned over the centuries. The 19th century saw the addition of Maid Marian: a man in women's clothing. Up to then the dancers wore their workaday clothes with a few pink and white rosettes fastened to them, but in the 1880s Mrs Lowe, the local vicar's wife, designed medieval-style costumes of knee breeches, jerkins and caps. The oak-leaf design on the current breeches was created by textile students at the University of Derby and is based on the pattern on the breeches in Sir Benjamin Stone's photographs of the event from the 1890s.

One of the curious things about this ritual is the antlers. In 1976, a small shard of antler that had come loose was radiocarbon dated to around 1065 (plus or minus eighty years). However, reindeer are thought to have been extinct in the UK at that time. Did they come from Scandinavia? This remains a puzzle and only adds to the custom's overall mystery, for no one knows its meaning.

The portraits in this book capture the passion people have for the customs in which they are taking part. The strengthening of a community's identity, the celebration of its individuality and the honouring of its history are important in an increasingly homogenous world. Henry's photographs are a wonderful celebration of a small but rich proportion of the many thousands of people who participate in customs and events throughout the UK each year.

Long may they uphold these traditions!

Diana, *Jack-in-the-Green*,
Hastings, East Sussex

OVERLEAF
LEFT Claire Humm, *Jack-in-the-Green*,
Hastings, East Sussex

RIGHT Bob Humm, *Jack-in-the-Green*,
Hastings, East Sussex

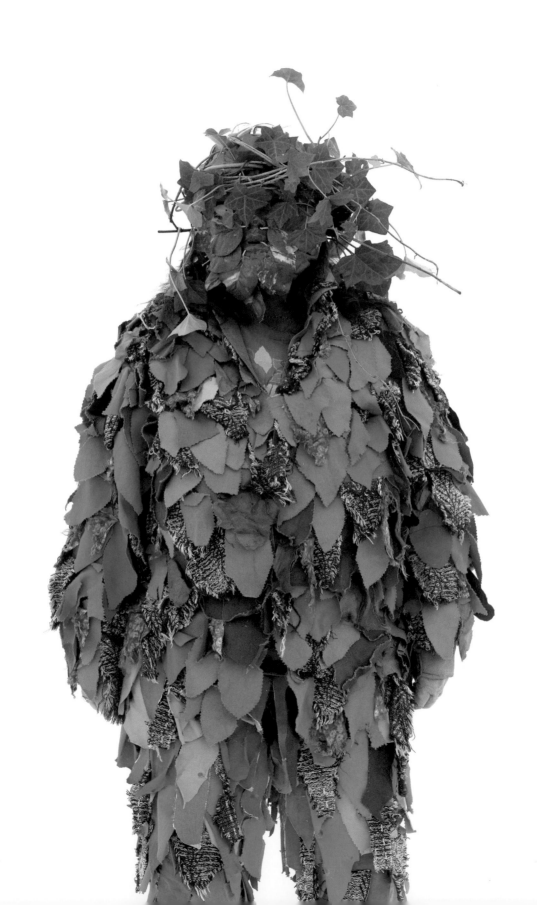

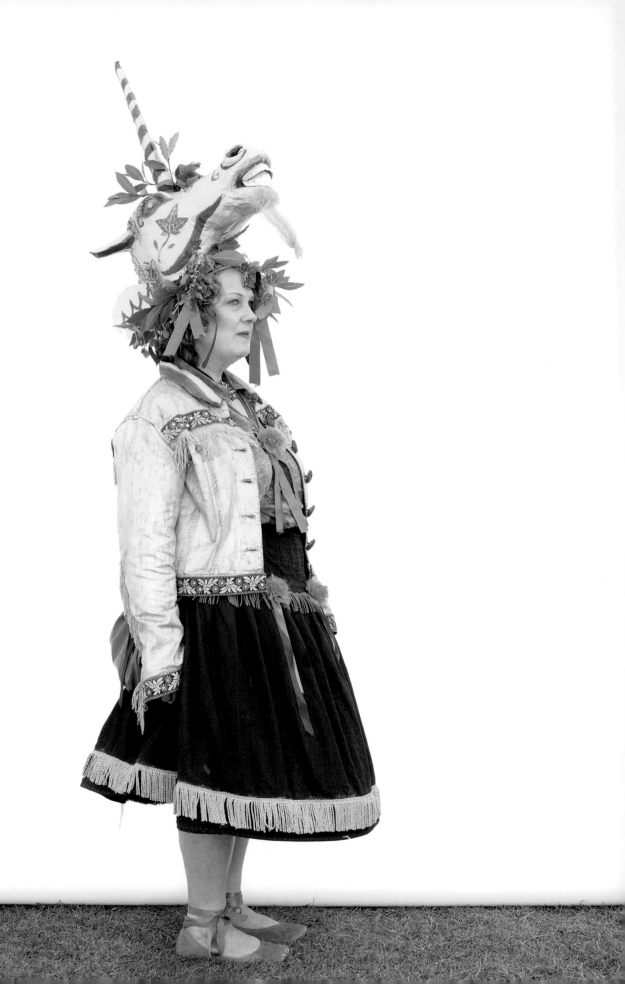

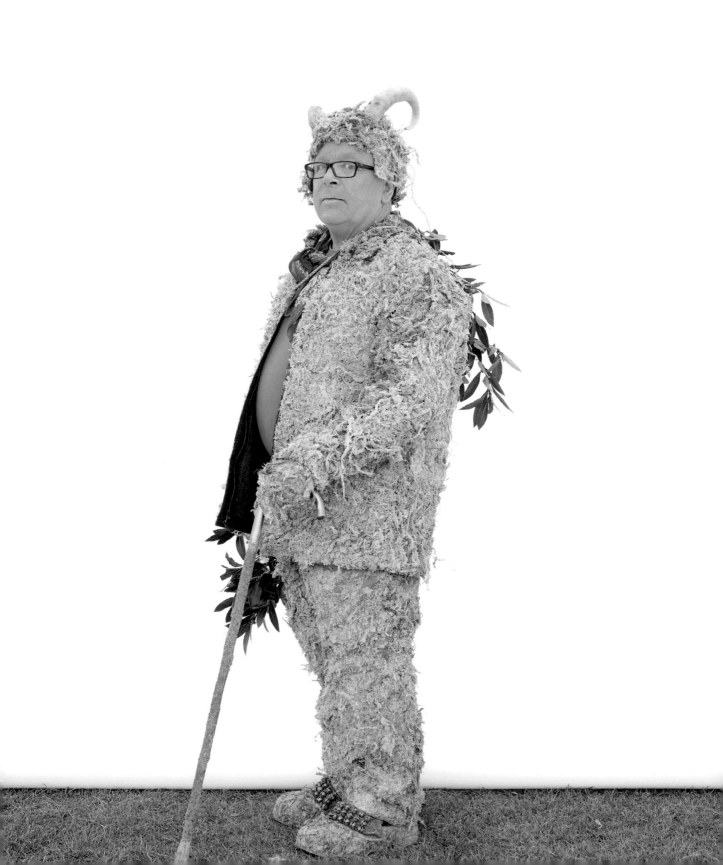

Jane Wildgoose,
Jack-in-the-Green,
Hastings, East Sussex

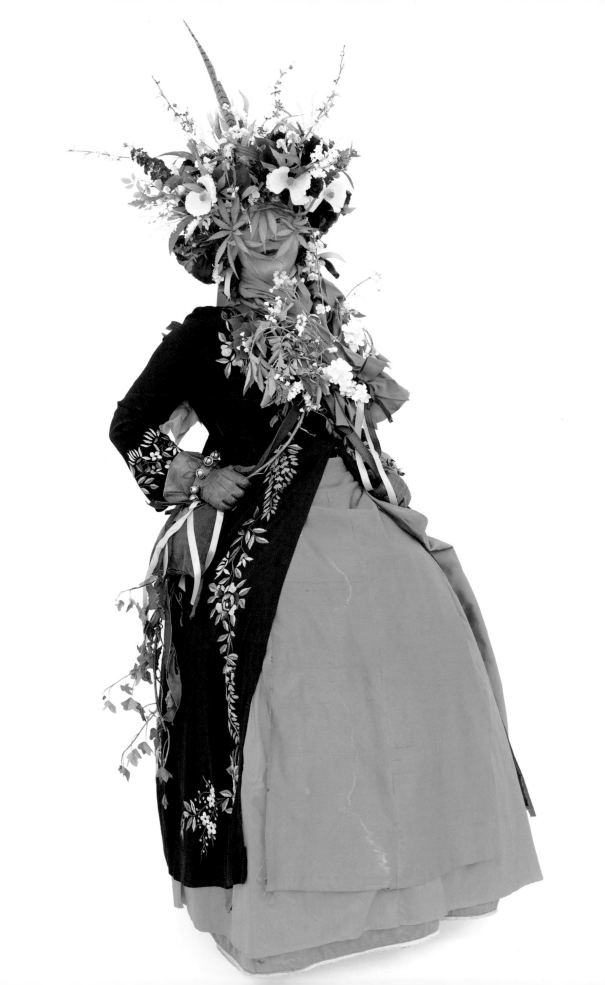

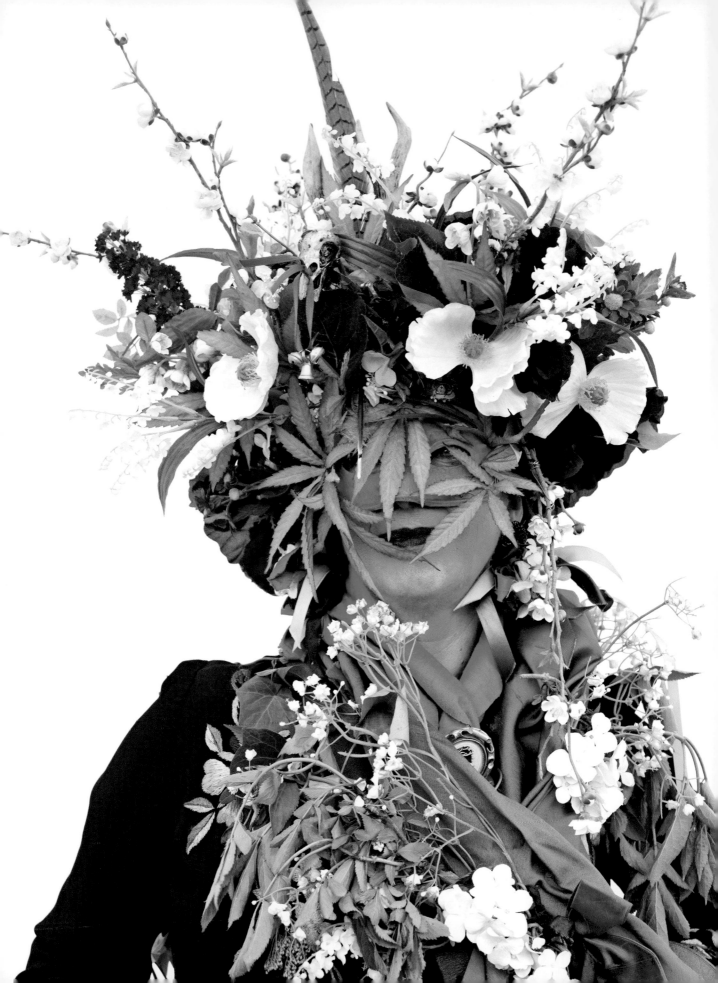

Jane Wildgoose, *Jack-in-the-Green*,
Hastings, East Sussex

OVERLEAF
Richard de Lord Wadhurst, *Jack-in-the-Green*, Hastings, East Sussex

21

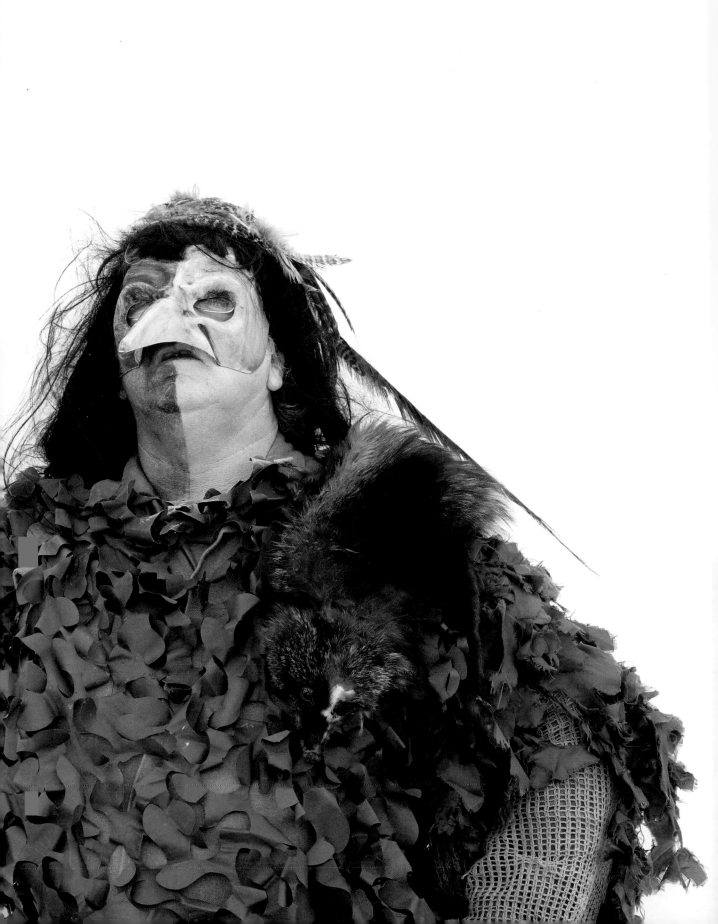

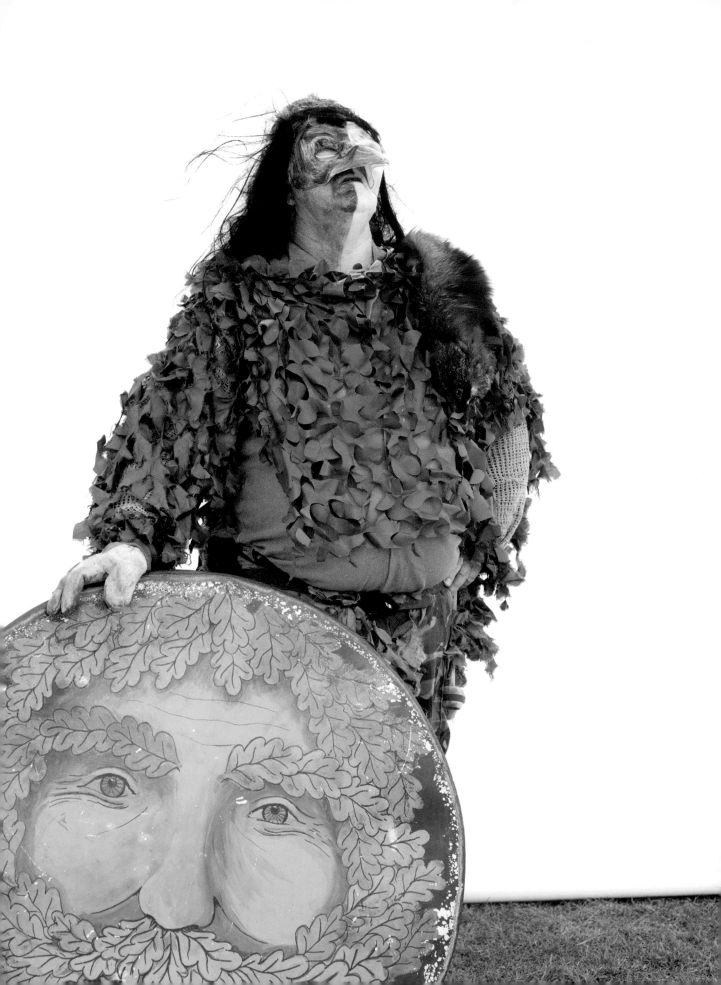

Gary and Rebecca Burnage, *HUNTERS MOON MORRIS*, *Jack-in-the-Green*, Hastings, East Sussex

OVERLEAF
LEFT Heather Burnage, *HUNTERS MOON MORRIS*, *Jack-in-the-Green*, Hastings, East Sussex

RIGHT Rob, *Jack-in-the-Green*, Hastings, East Sussex

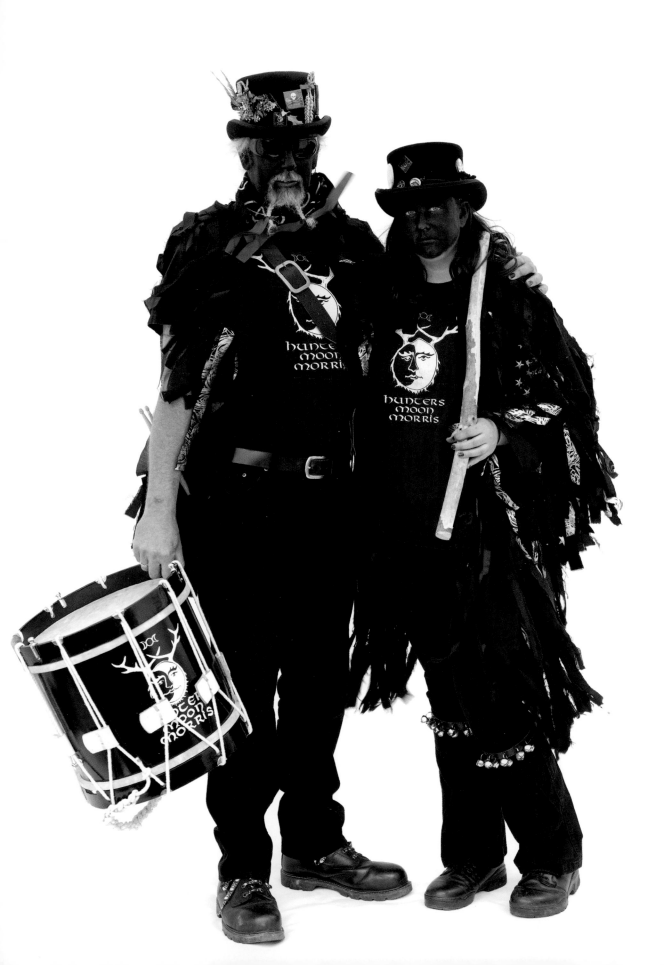

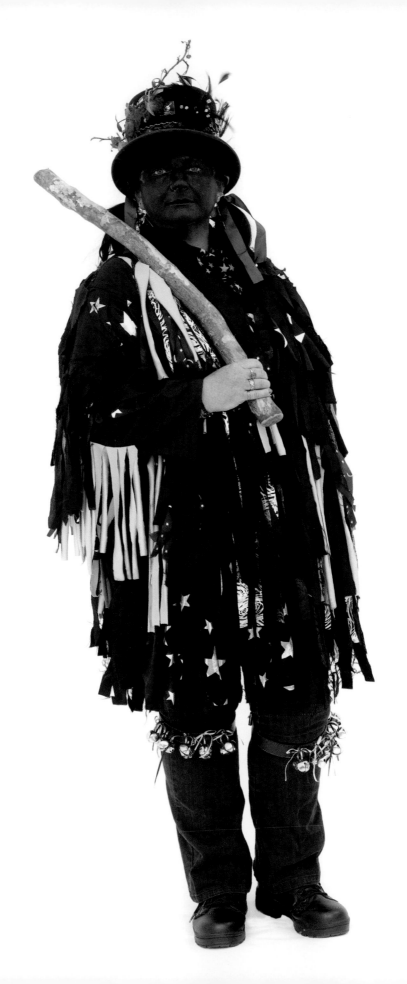

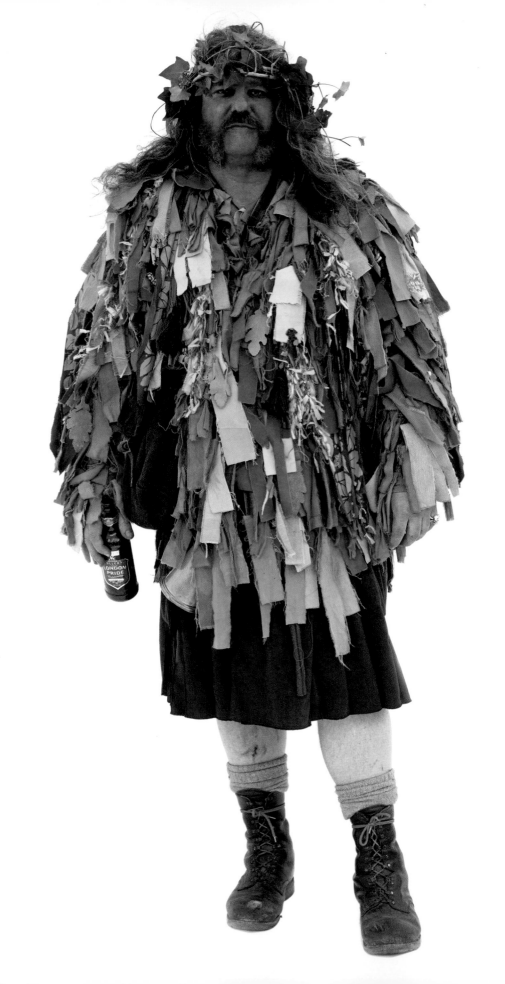

Bogie Paul, *Jack-in-the-Green*,
Hastings, East Sussex

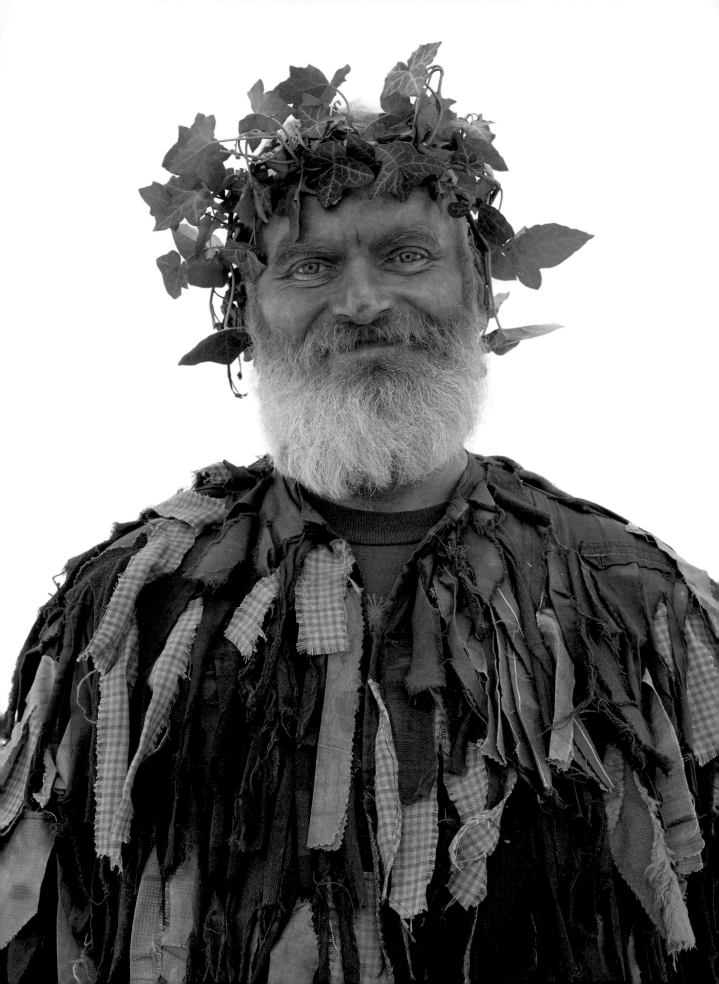

Tony Slater, *Jack-in-the-Green*,
Hastings, East Sussex

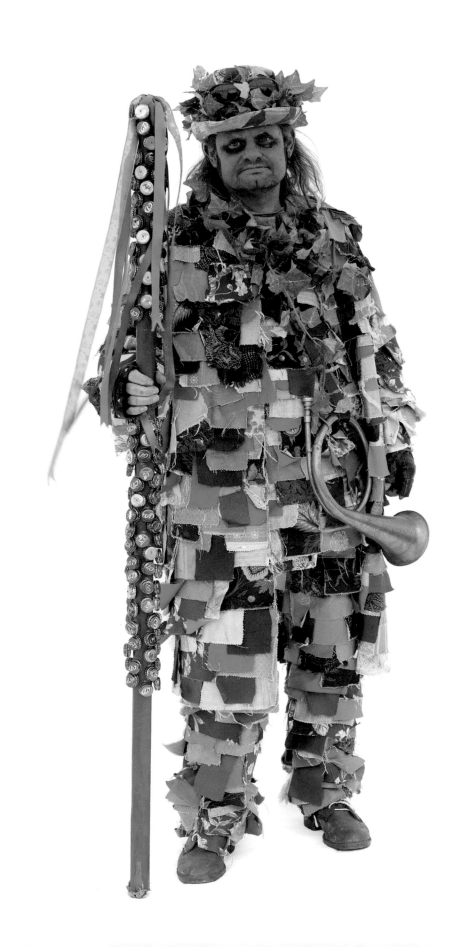

Rodger Molyneux, *Jack-in-the-Green*,
Hastings, East Sussex

OVERLEAF, LEFT AND RIGHT
Phil, *Jack-in-the-Green*, Hastings,
East Sussex

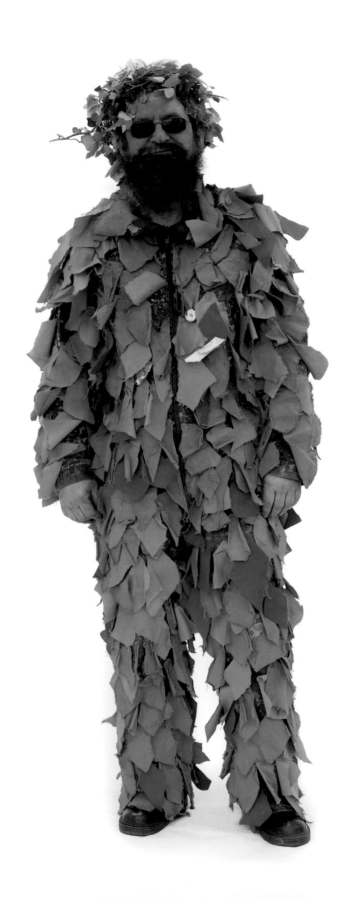

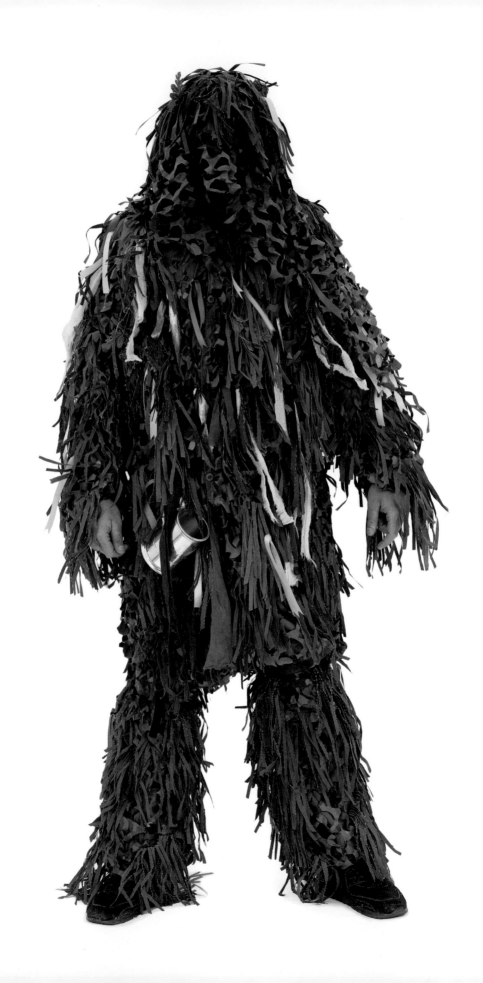

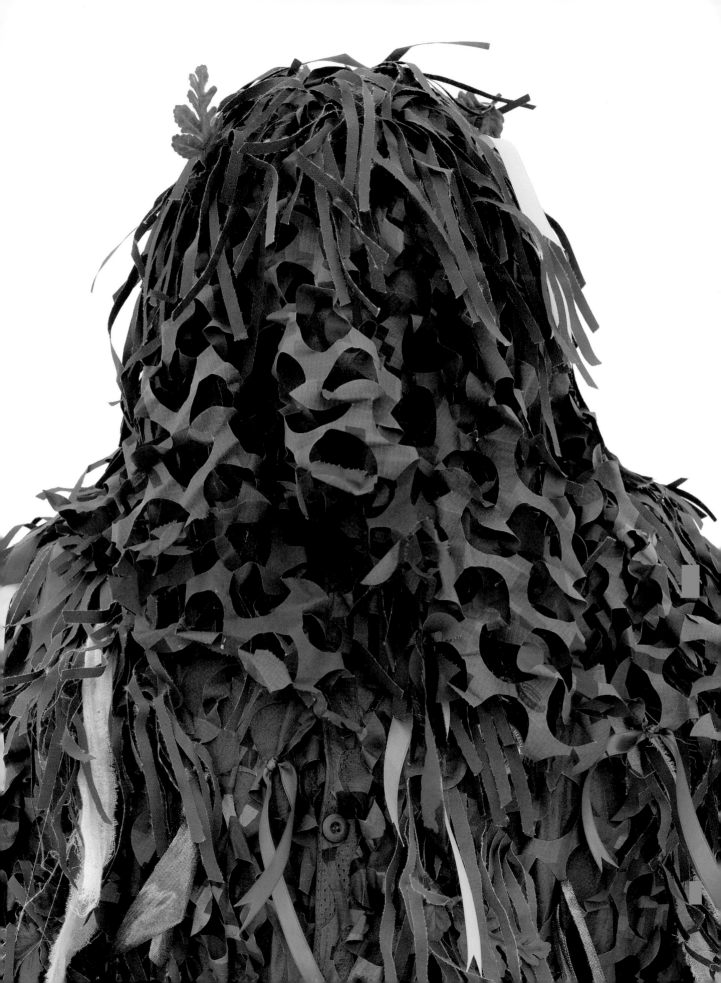

Martyn Brisland (lorry driver),
RUTLAND MORRIS, *Whittlesea
Straw Bear Festival*, Whittlesey,
Cambridgeshire

OVERLEAF
LEFT Paul Whiting, *RED LEICESTER
MORRIS*, *Whittlesea Straw Bear Festival*,
Whittlesey, Cambridgeshire

RIGHT Pete Williams (gas engineer),
Whittlesea Straw Bear Festival,
Whittlesey, Cambridgeshire

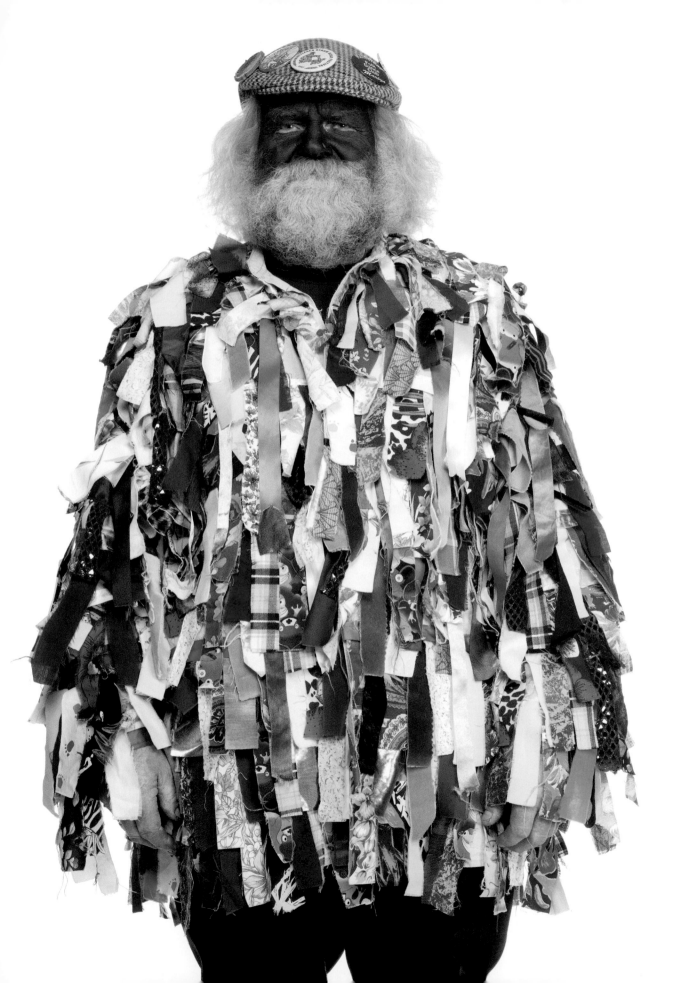

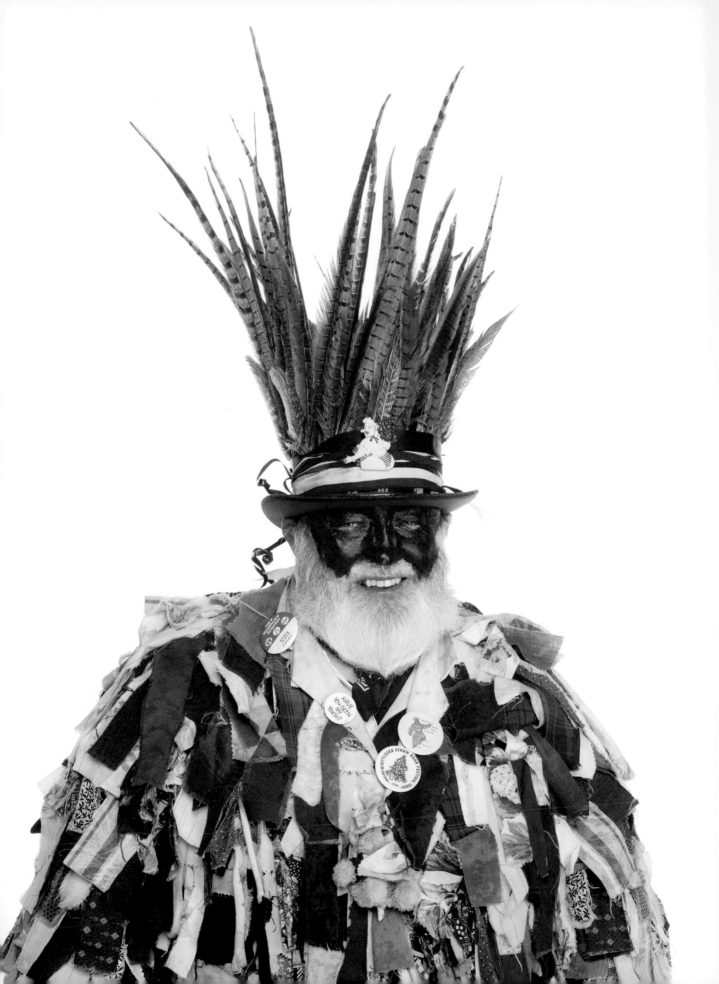

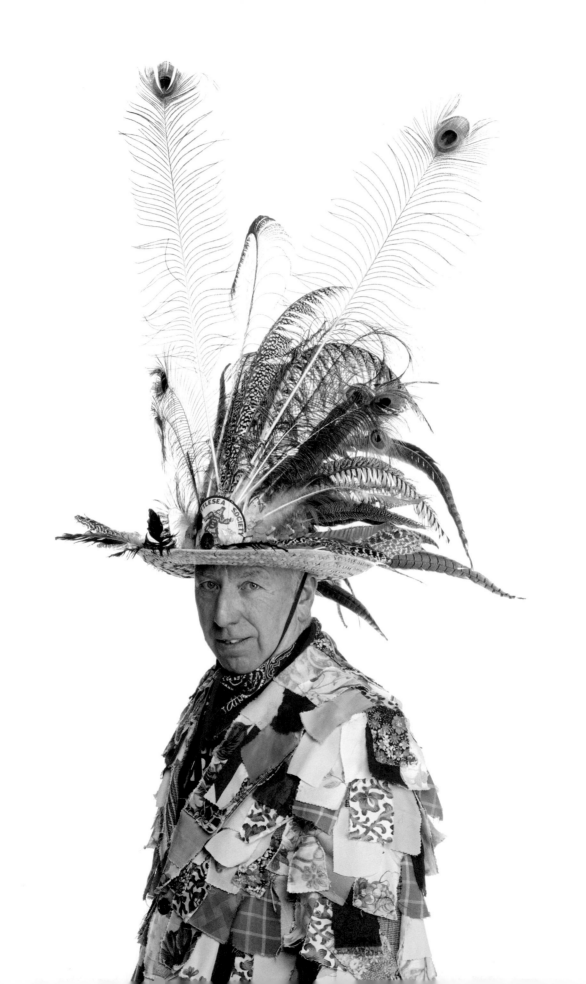

Alan Ollenbittle, *Whittlesea Straw Bear Festival*, Whittlesey, Cambridgeshire

OVERLEAF
LEFT Christian Cornell (student), *THE STRAW BEAR*, *Whittlesea Straw Bear Festival*, Whittlesey, Cambridgeshire

RIGHT Oliver Cross, *THE LITTLE BEAR*, *Whittlesea Straw Bear Festival*, Whittlesey, Cambridgeshire

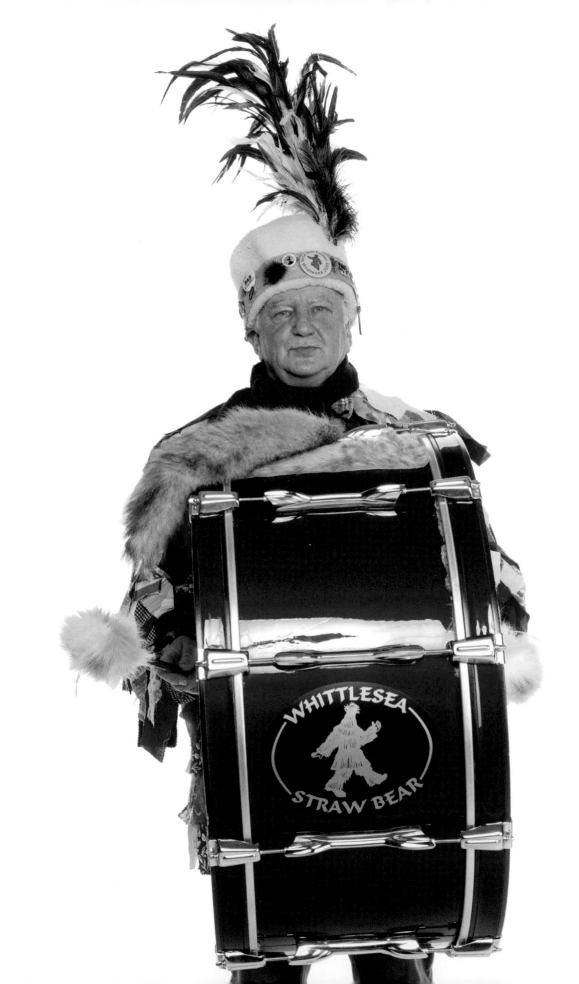

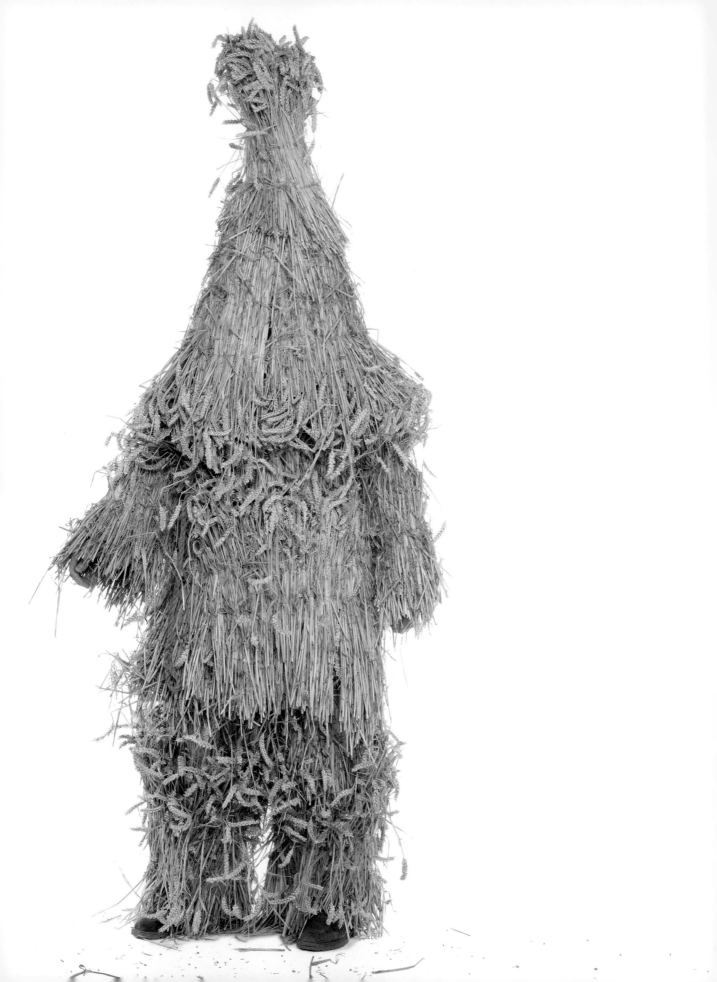

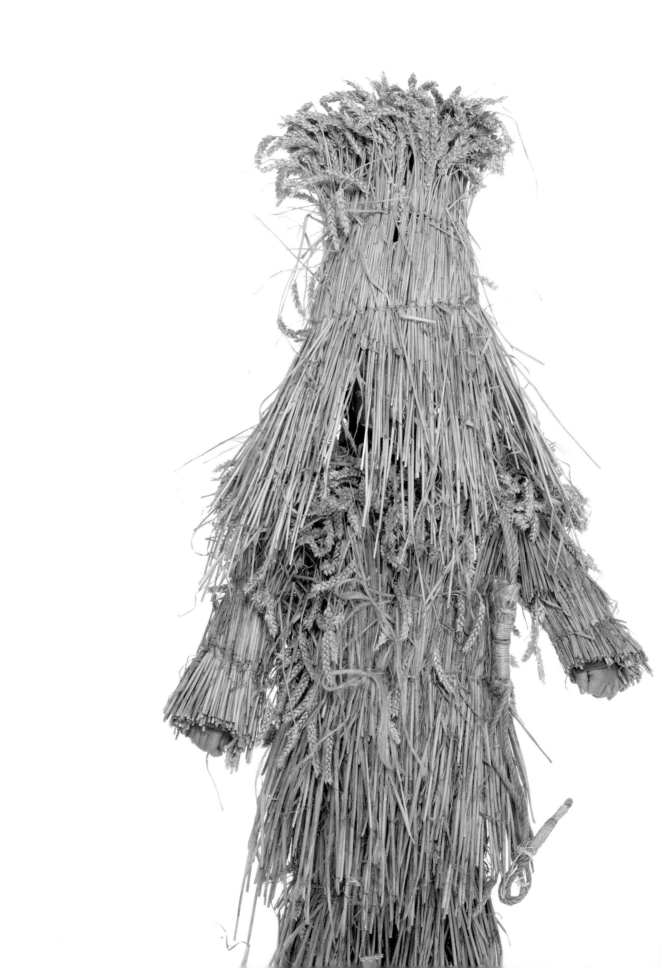

Wodro Green, *DEER KEEPER*,
Whittlesea Straw Bear Festival,
Whittlesey, Cambridgeshire

OVERLEAF
LEFT Derek Legg, *Jack-in-the-Green*,
Hastings, East Sussex

RIGHT Philip Tyler and Eleanor Pearl,
Jack-in-the-Green, Hastings, East Sussex

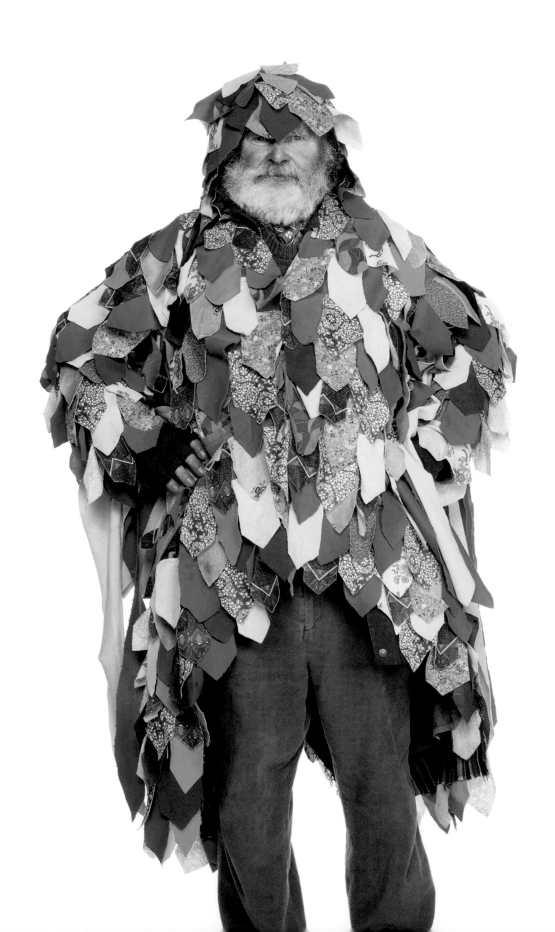

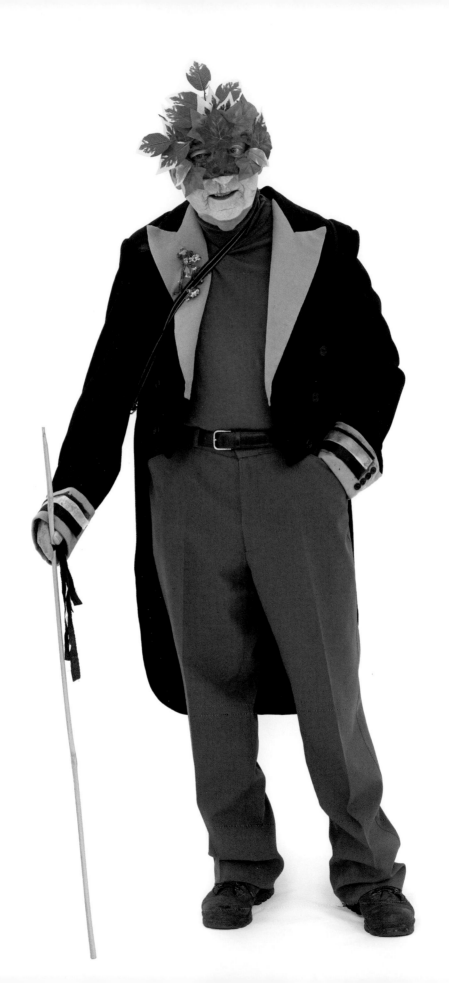

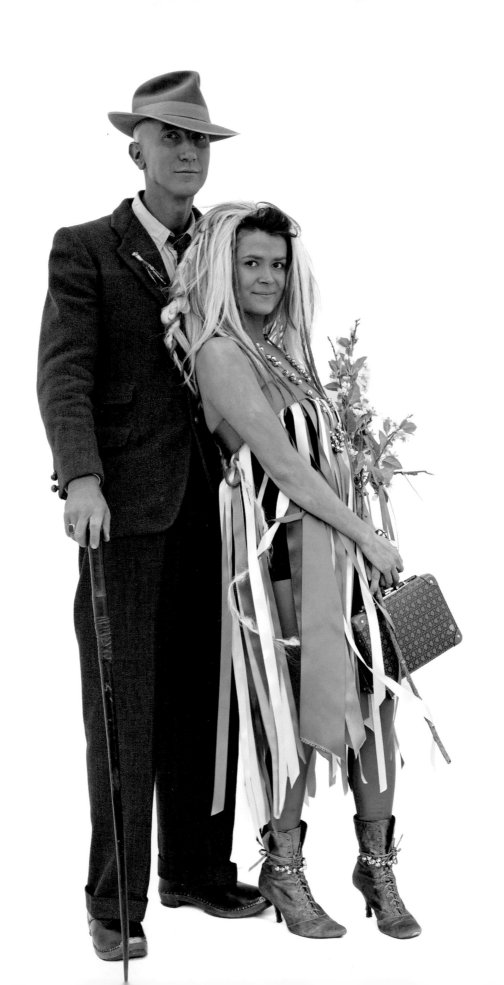

Francis Rowe, *Jack-in-the-Green*,
Hastings, East Sussex

OVERLEAF, LEFT AND RIGHT
Spencer Horne, *GAY BOGIE*, *Jack-in-the-Green*, Hastings, East Sussex

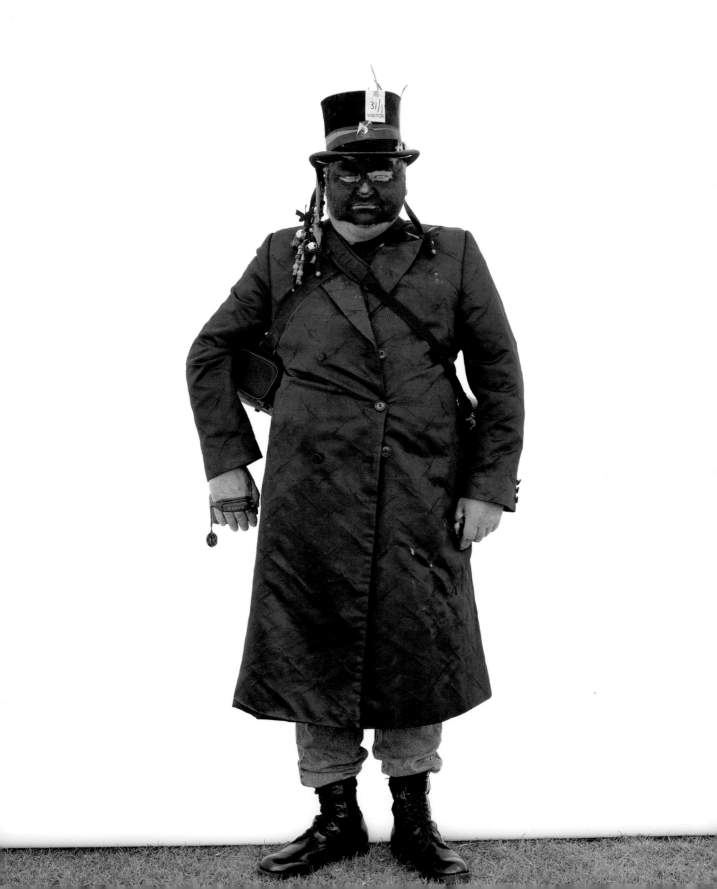

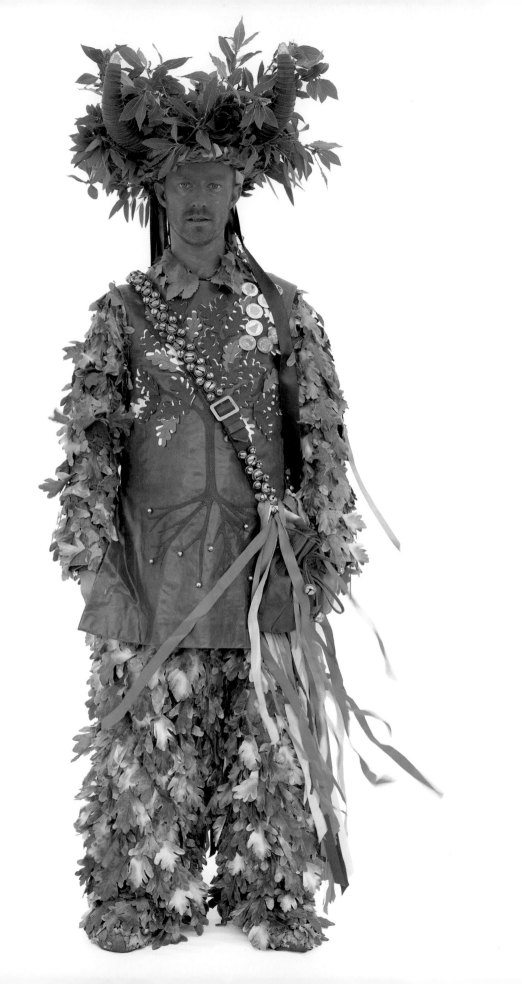

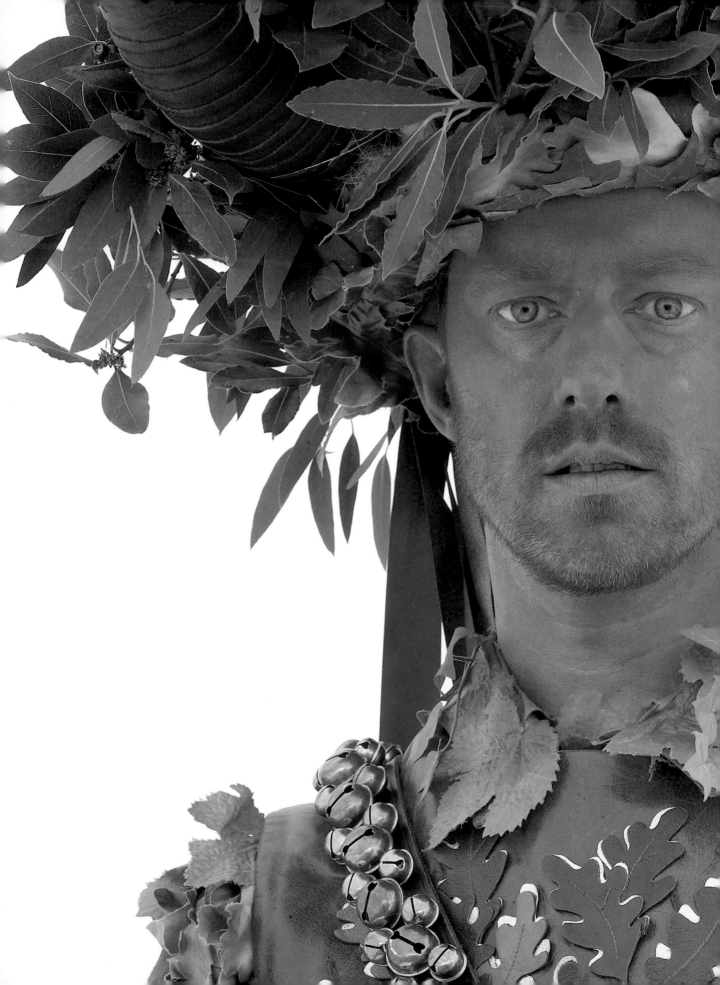

John Pond, *SECTION 5 DRUMMER*,
Jack-in-the-Green, Hastings, East Sussex

OVERLEAF
LEFT Julia Bovee, *GAY BOGIE*,
Jack-in-the-Green, Hastings, East Sussex

RIGHT Jill Whiting, *Jack-in-the-Green*,
Hastings, East Sussex

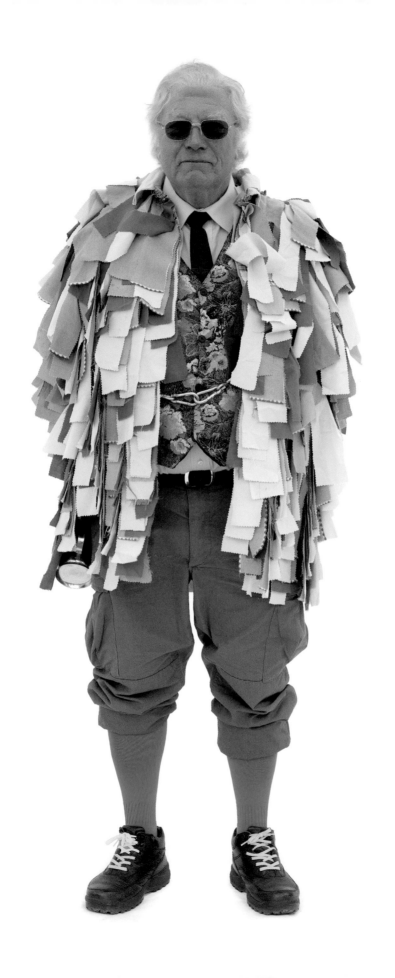

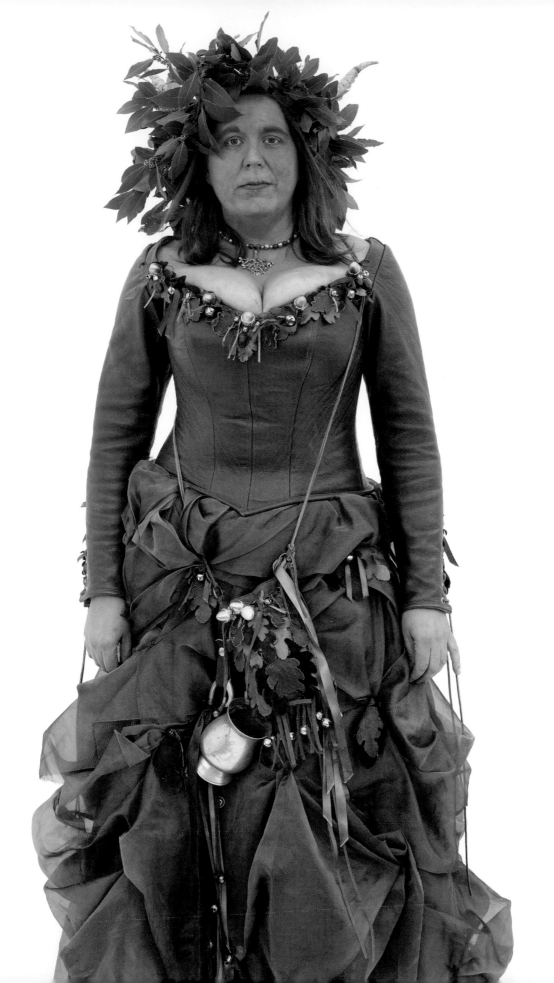

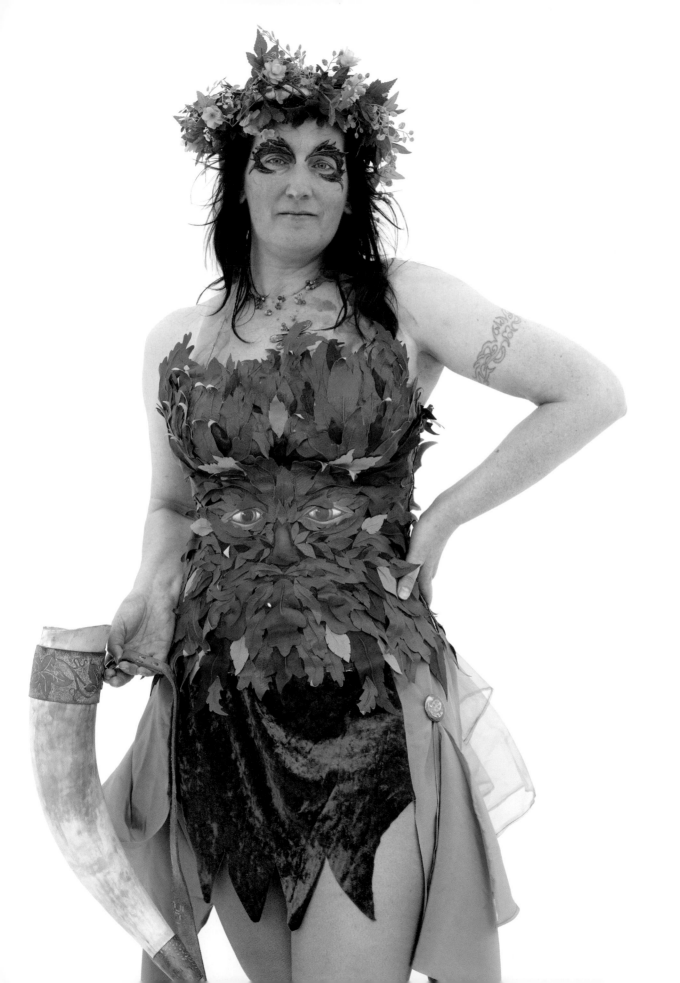

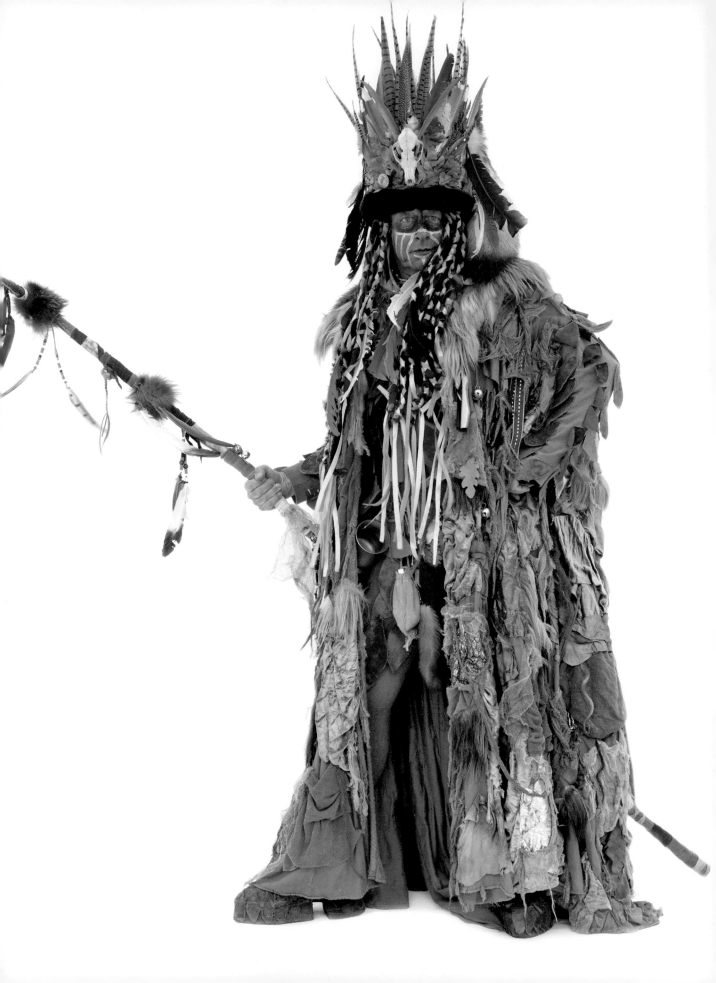

Mick Bovee, *GAY BOGIE*, *Jack-in-the-Green*, Hastings, East Sussex

Simon Costin (director of the Museum
of British Folklore), *Jack-in-the-Green*,
Hastings, East Sussex

OVERLEAF
LEFT Christine Hanson, *OLD STAR
MORRIS*, *Jack-in-the-Green*, Hastings,
East Sussex

RIGHT Craig Sheppard, *Jack-in-the-
Green*, Hastings, East Sussex

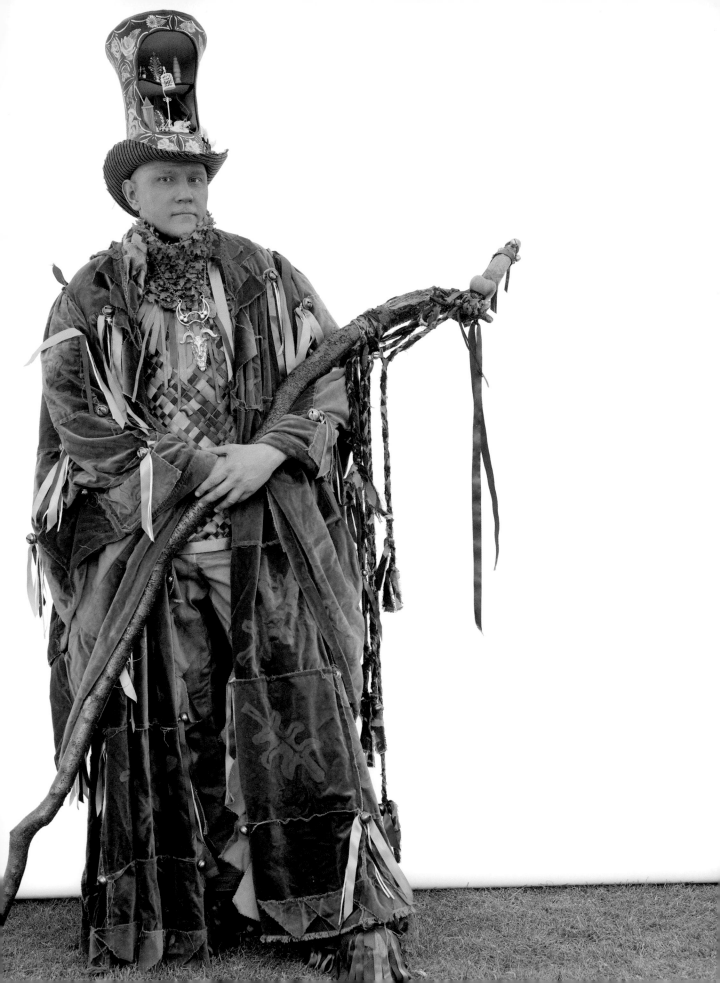

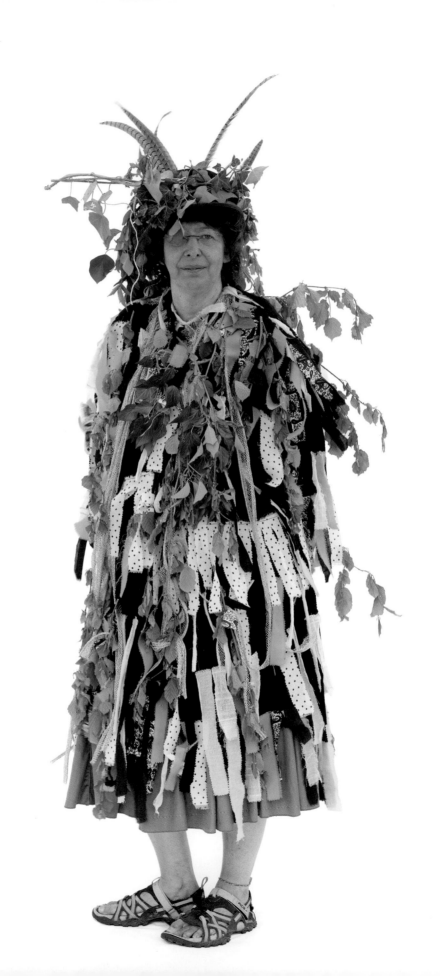

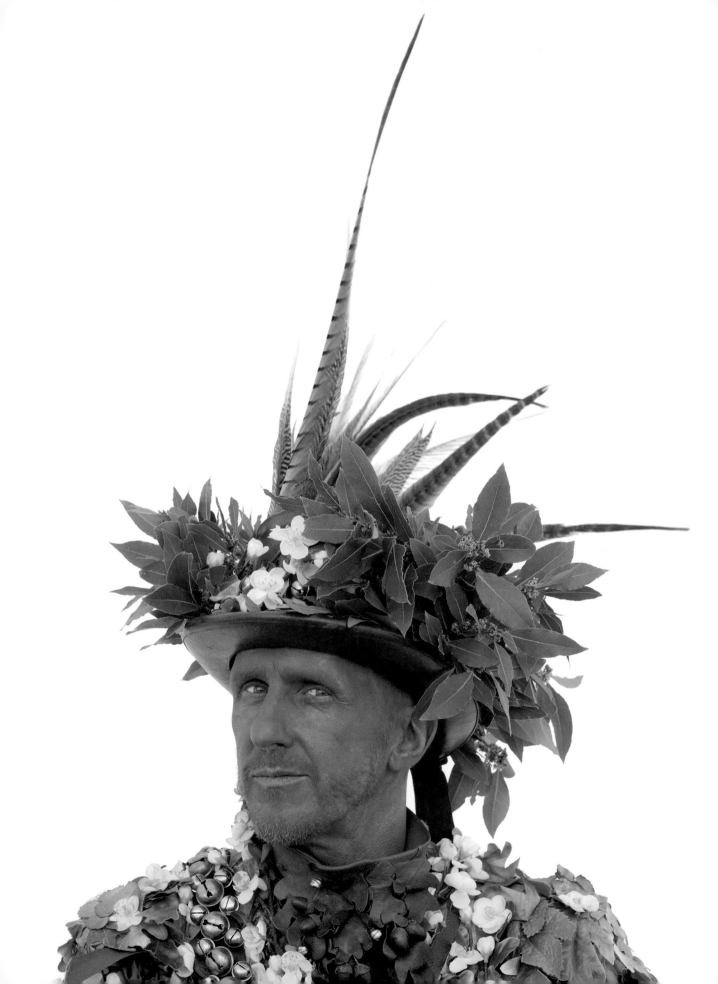

Helen Evans, *BLACK SAL*, *Jack-in-the-Green*, Hastings, East Sussex

.

OVERLEAF, LEFT AND RIGHT
Colin Stubbs, *Jack-in-the-Green*,
Hastings, East Sussex

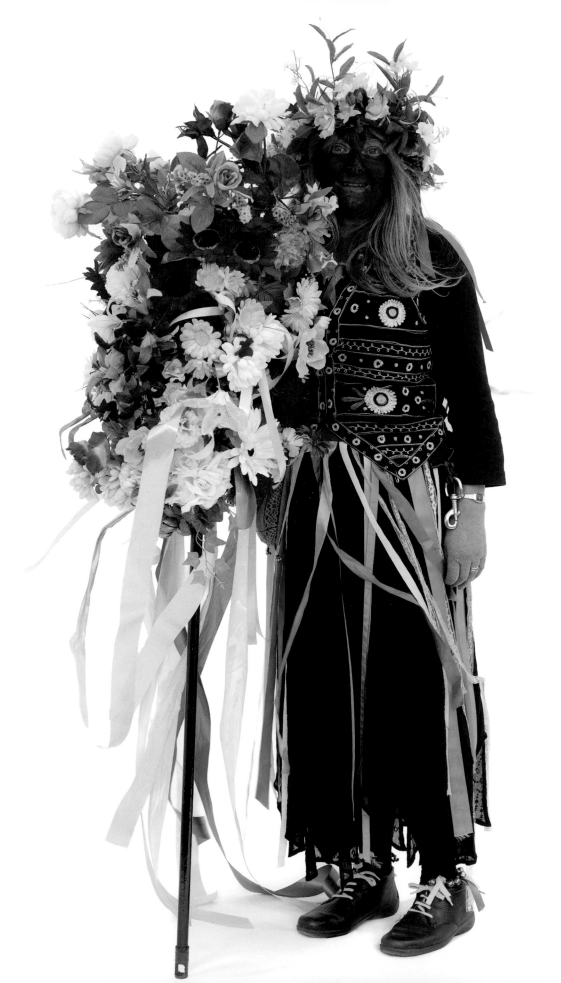

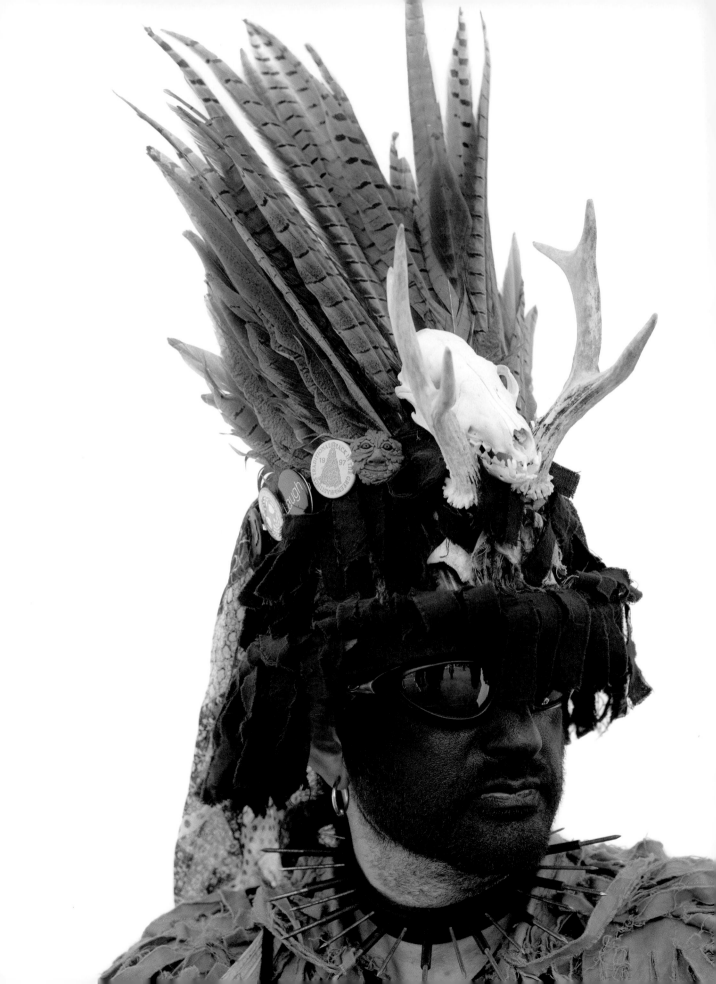

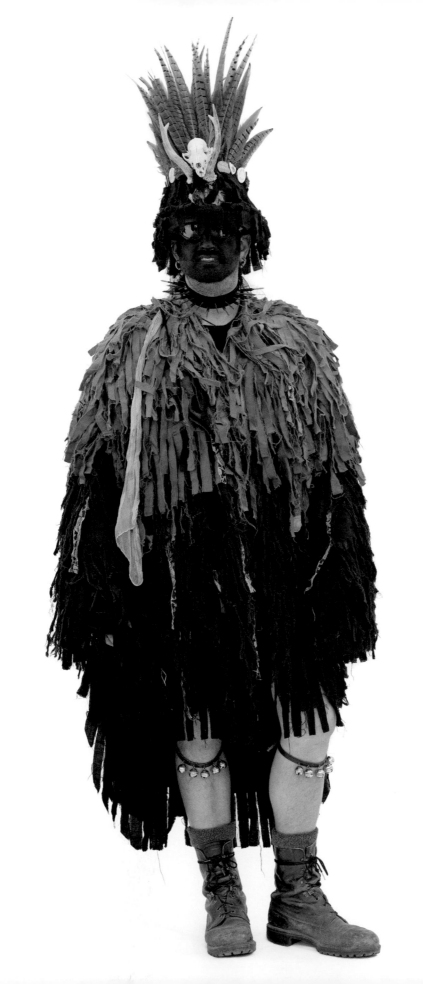

Ray McLeever, Jeanette Rowell and
Ranger the dog, *Jack-in-the-Green*,
Hastings, East Sussex

OVERLEAF
LEFT Benjamin Robinson, *RABBLE
FOLK THEATRE, KENT*, *Jack-in-the-
Green*, Hastings, East Sussex

RIGHT Adam Robinson, *Jack-in-the-
Green*, Hastings, East Sussex

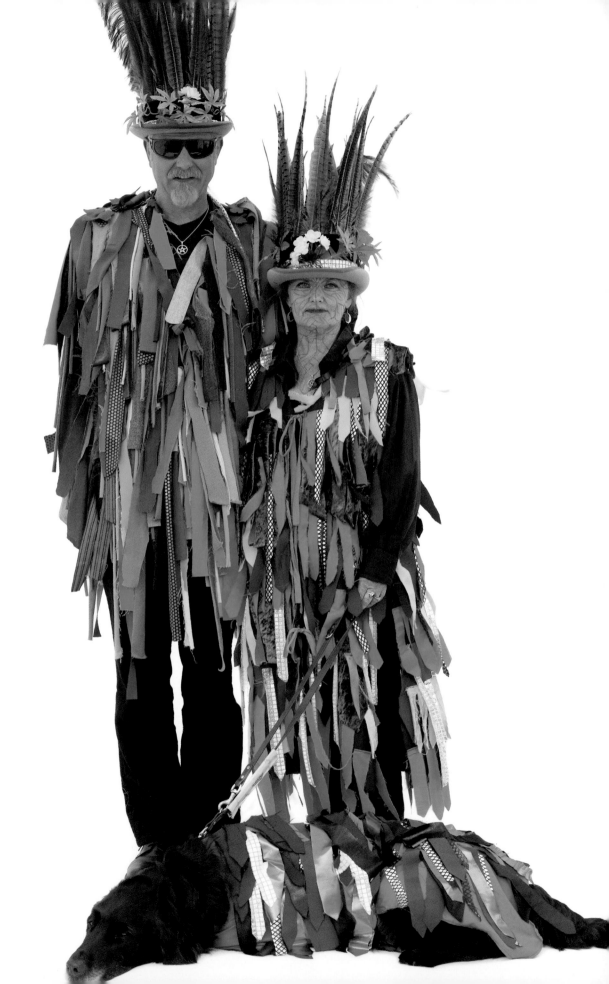

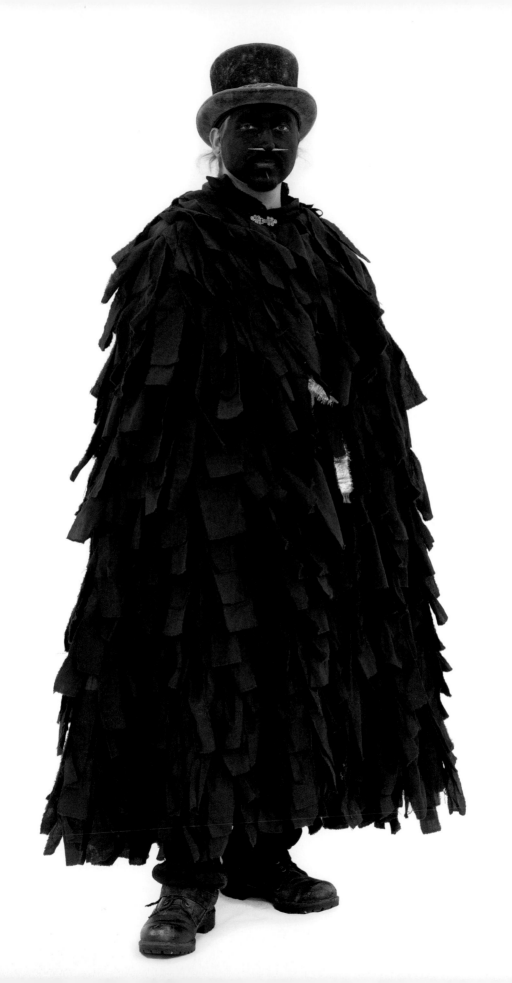

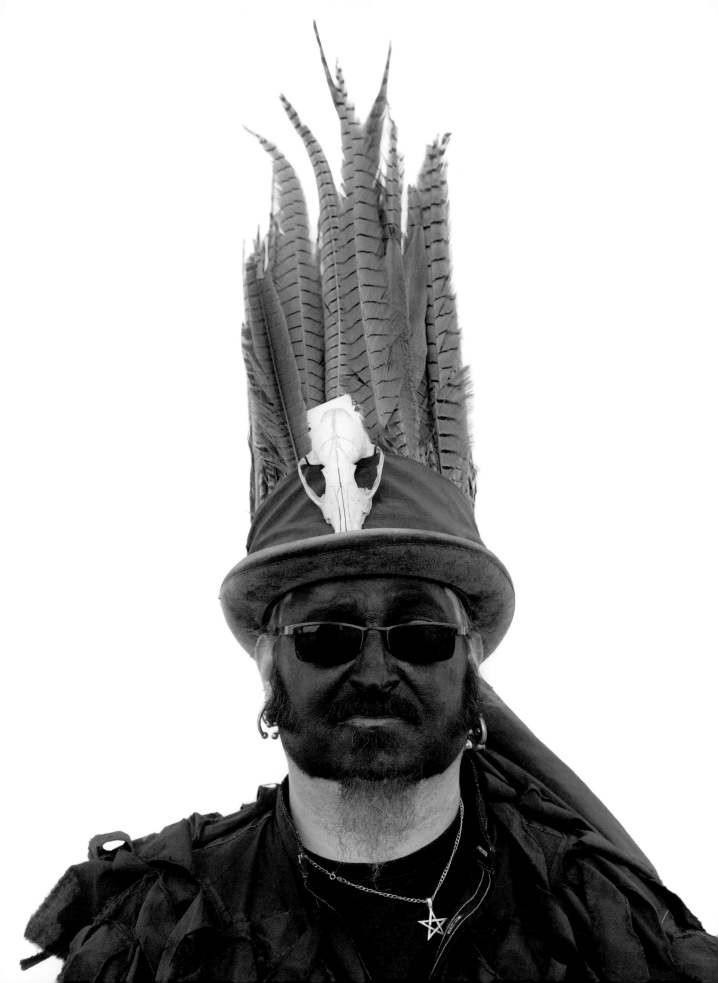

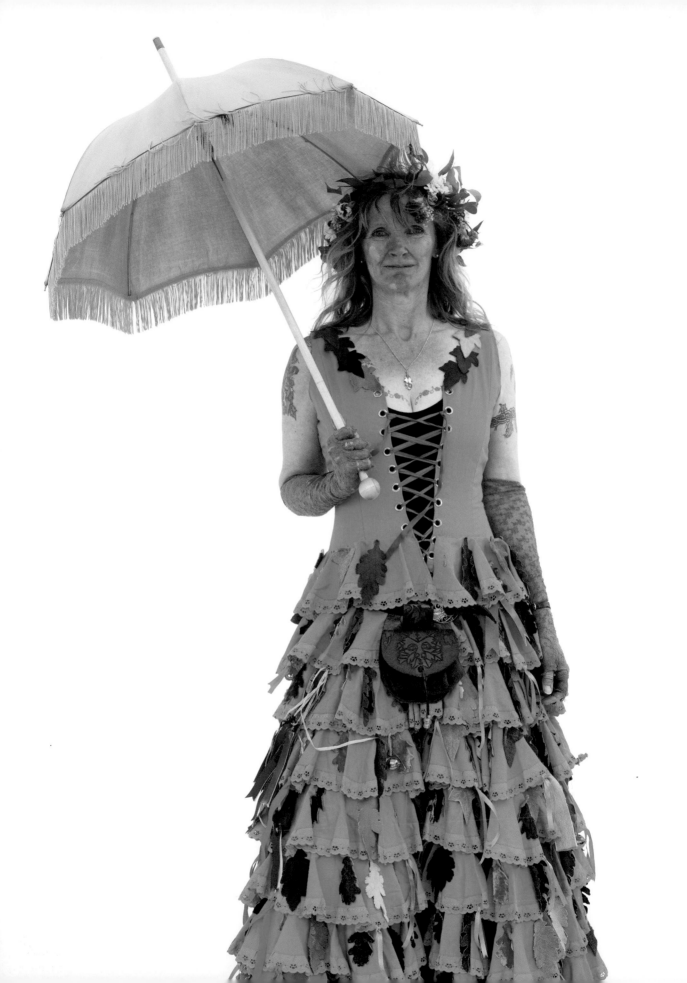

Rachel Robert, *Jack-in-the-Green*,
Hastings, East Sussex

OVERLEAF
LEFT Piers Blackmore and Conee,
Jack-in-the-Green, Hastings, East Sussex

RIGHT Jill Pring, *OLD GLORY MOLLY*,
Whittlesea Straw Bear Festival,
Whittlesey, Cambridgeshire

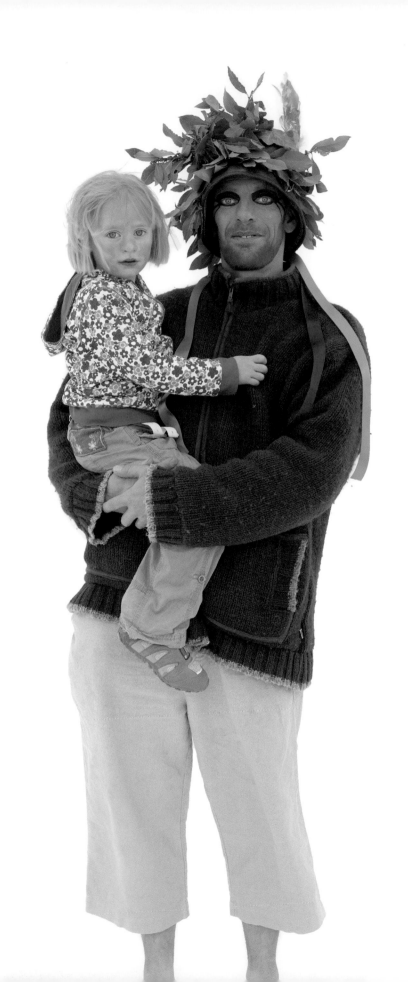

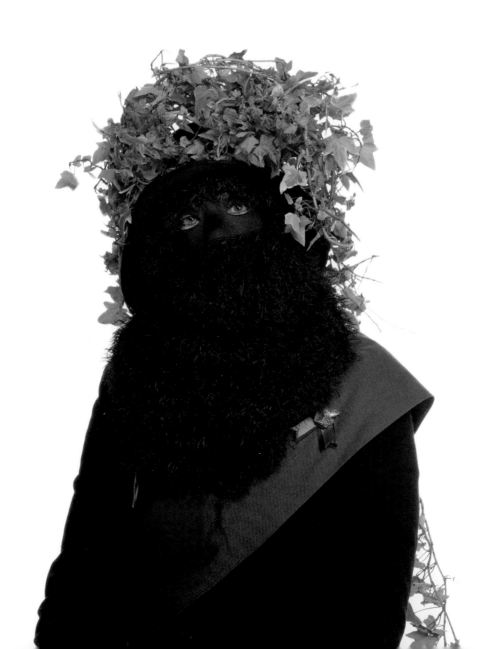

Jill Pring, OLD GLORY MOLLY,
Whittlesea Straw Bear Festival,
Whittlesey, Cambridgeshire

OVERLEAF
LEFT Nicky Elliot, OLD GLORY
MOLLY, *Whittlesea Straw Bear Festival*,
Whittlesey, Cambridgeshire

RIGHT Polly Kimm, OLD GLORY
MOLLY, *Whittlesea Straw Bear Festival*,
Whittlesey, Cambridgeshire

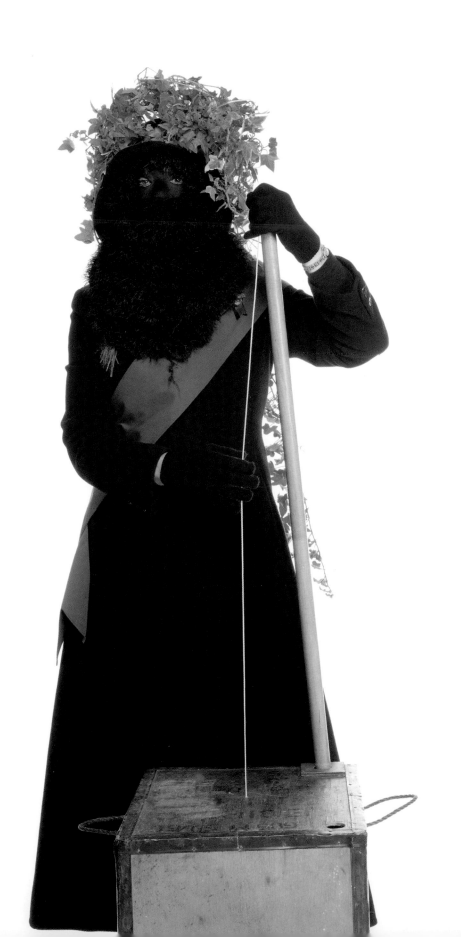

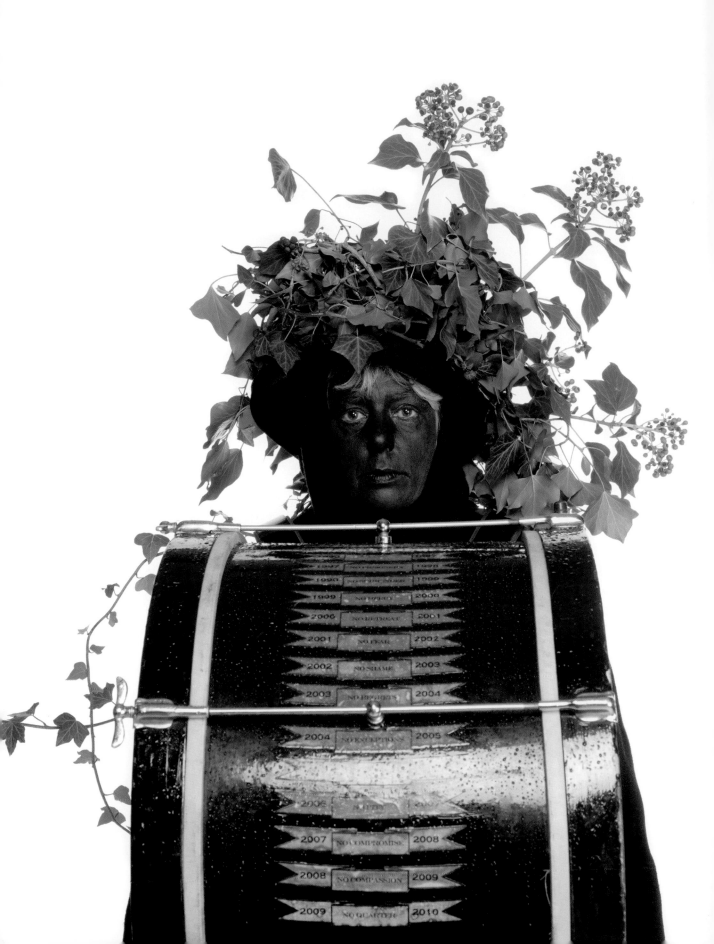

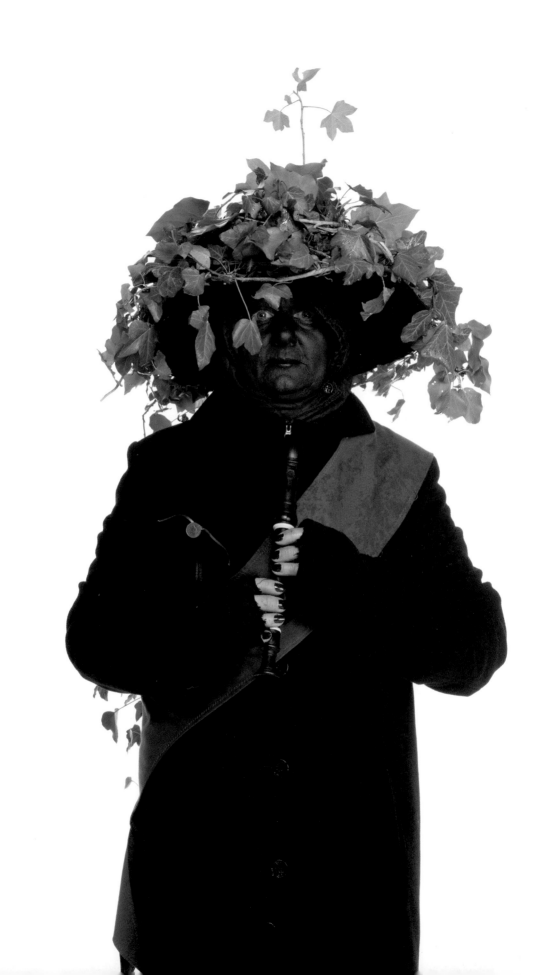

Ken May and Black Lord Crix of
Rumvurgh, *OLD GLORY MOLLY*,
Whittlesea Straw Bear Festival,
Whittlesey, Cambridgeshire

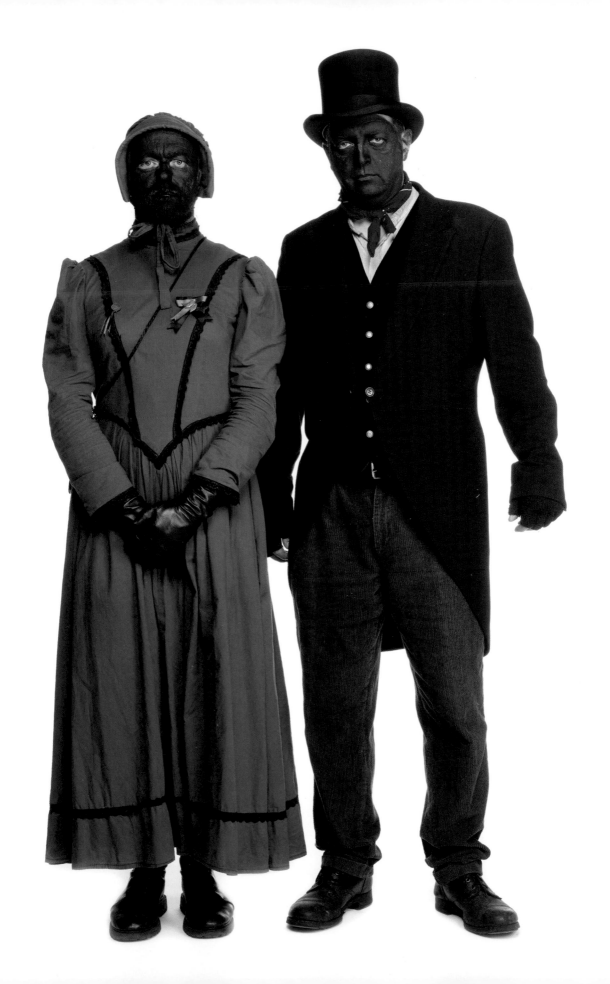

Wendy Sexton, *LEWES BOROUGH*
BONFIRE SOCIETY, *Bonfire Night*,
Hastings, East Sussex

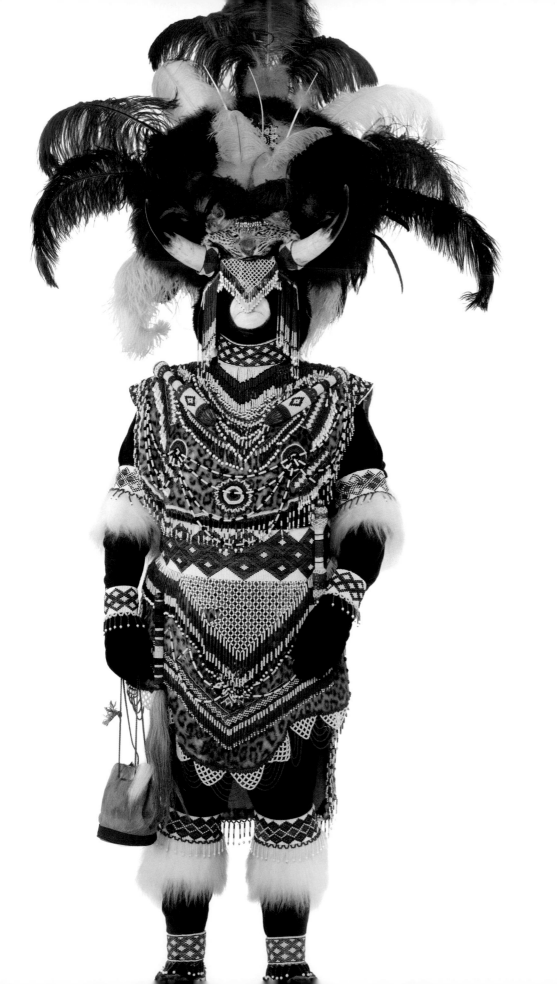

Gill and Peter Cherriman, *LEWES BOROUGH BONFIRE SOCIETY*, *Bonfire Night*, Hastings, East Sussex

OVERLEAF
LEFT Darren Walters, *PRINCE OF FINSBURY, PEARLY KINGS AND QUEENS*, *Wimbledon Village Fair*, London

RIGHT Lily York, *QUEEN OF SMITHFIELD MARKET, PEARLY KINGS AND QUEENS*, *Wimbledon Village Fair*, London

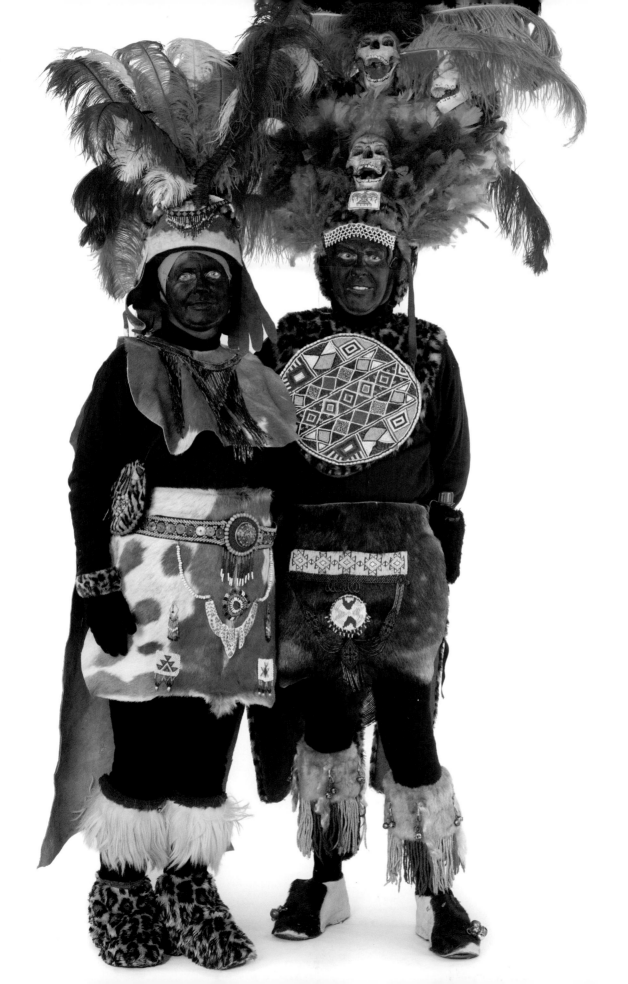

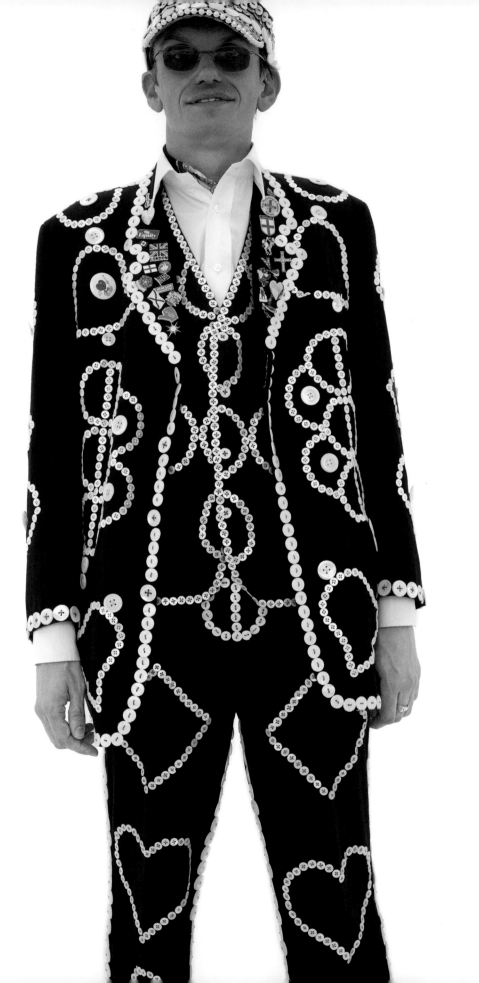

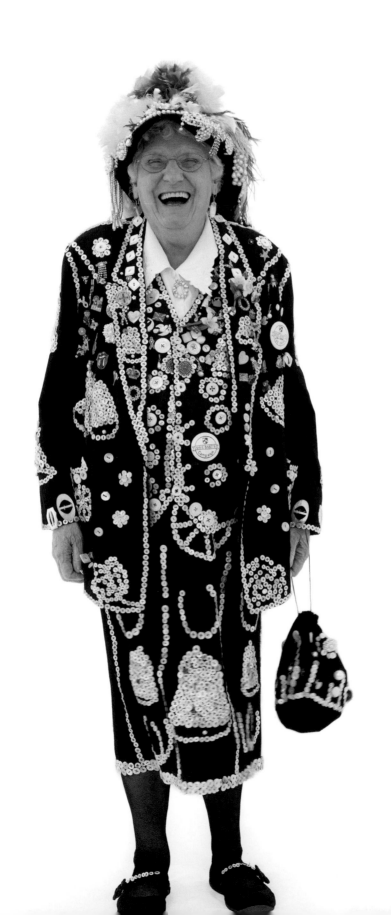

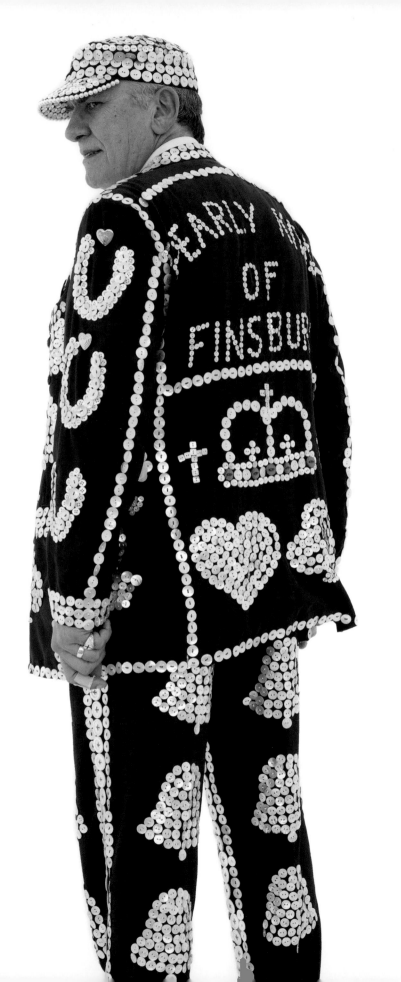

John Walters, *KING OF FINSBURY*,
PEARLY KINGS AND QUEENS,
Wimbledon Village Fair, London

Pip Gasson, *EWHURST AND STAPLECROSS BONFIRE SOCIETY*, *Bonfire Night*, Hastings, East Sussex

OVERLEAF
LEFT Pip Gasson, *EWHURST AND STAPLECROSS BONFIRE SOCIETY*, *Bonfire Night*, Hastings, East Sussex

RIGHT Derek Stone, *EWHURST AND STAPLECROSS BONFIRE SOCIETY*, *Bonfire Night*, Hastings, East Sussex

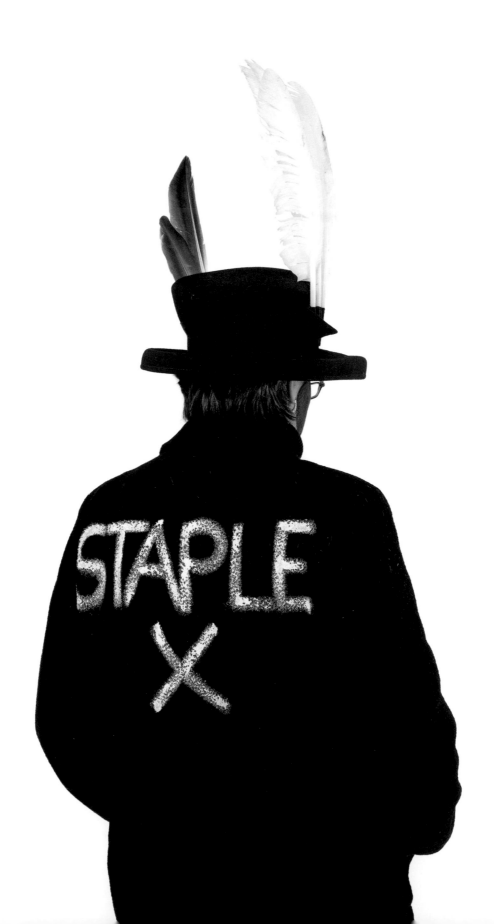

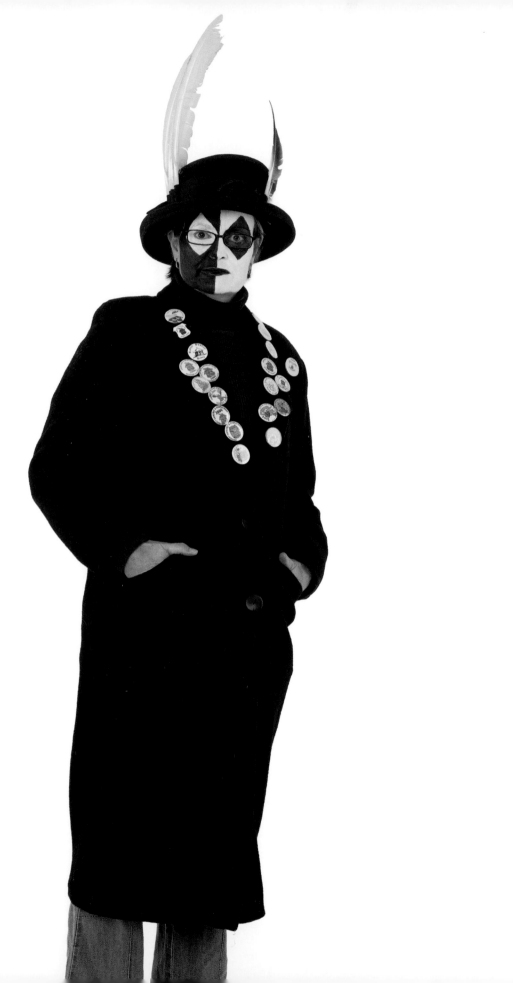

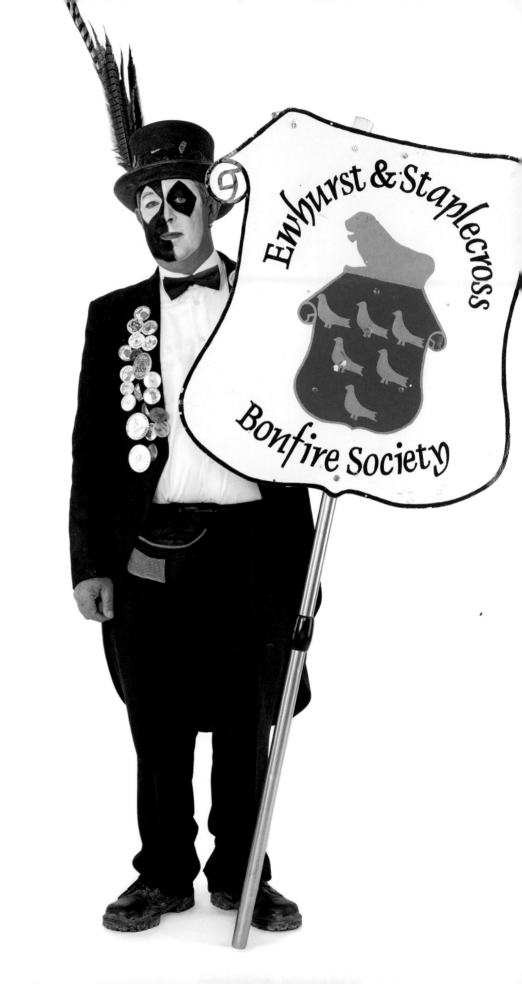

Ros Saunders, *Bonfire Night*,
Hastings, East Sussex

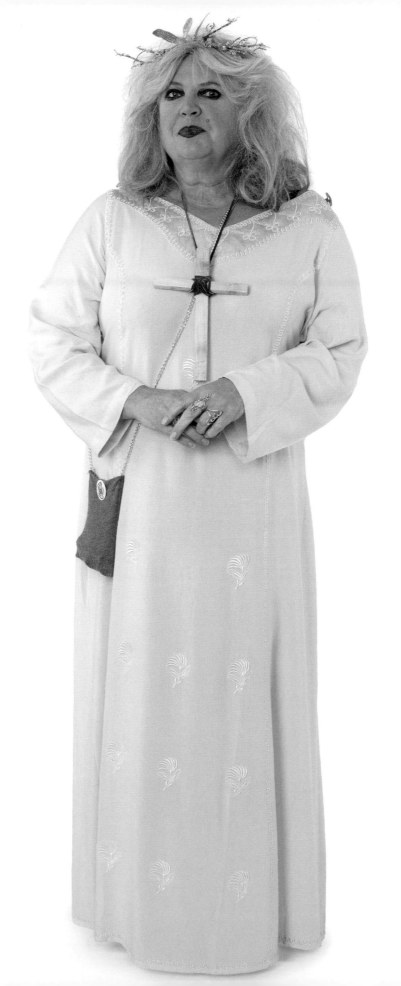

Damian Waterhouse, *Bonfire Night*,
Hastings, East Sussex

OVERLEAF
LEFT Unknown, *Bonfire Night*,
Hastings, East Sussex

RIGHT James Morgan, *Bonfire Night*,
Hastings, East Sussex

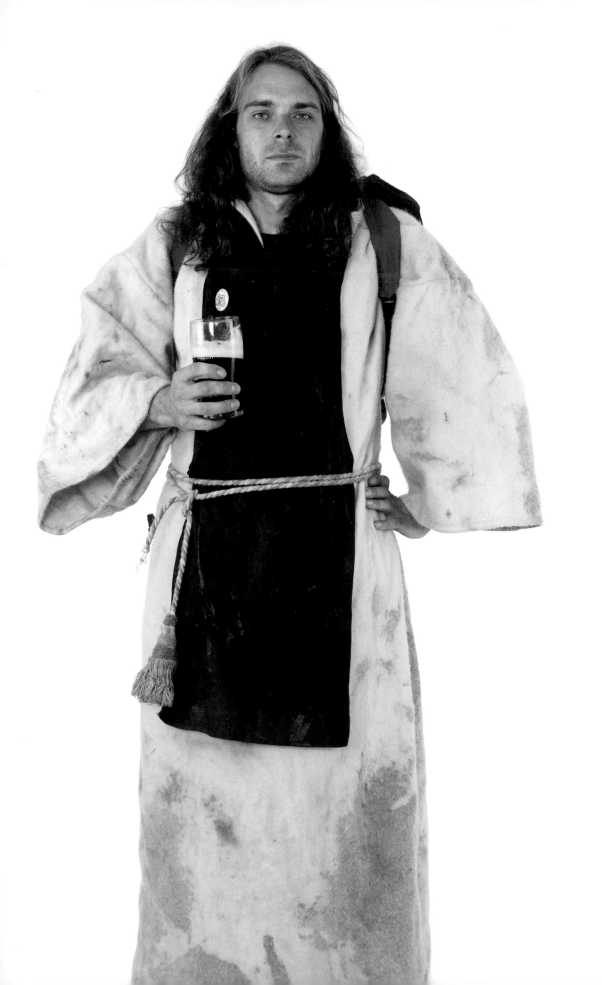

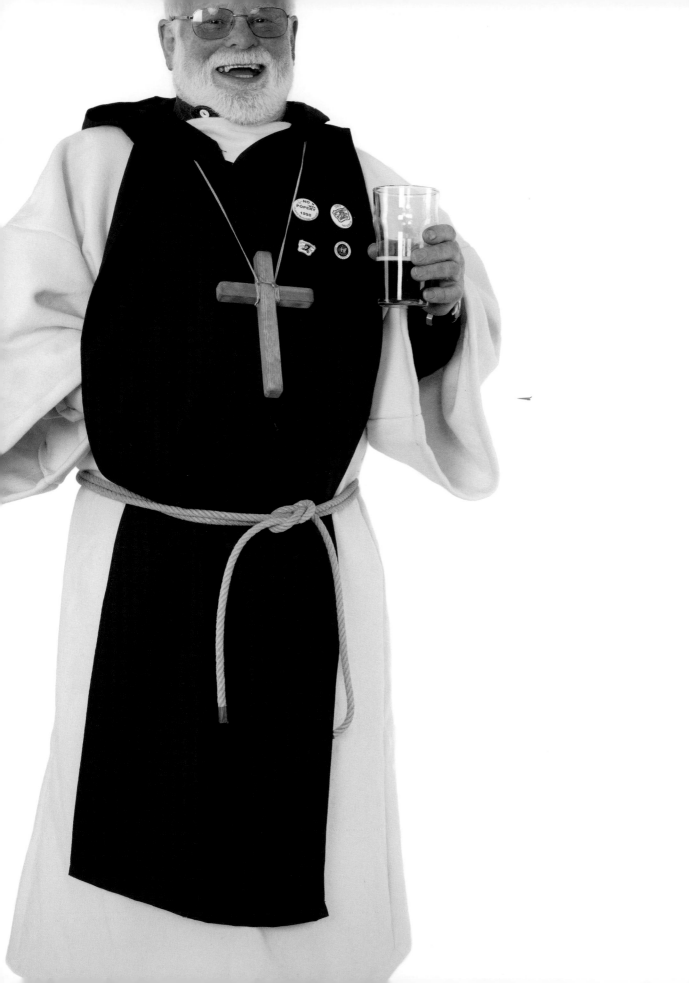

Andy Daniel (hospital porter),
Whittlesea Straw Bear Festival,
Whittlesey, Cambridgeshire

OVERLEAF
LEFT Unknown, *Jack-in-the-Green*,
Hastings, East Sussex

RIGHT Terry Bailey, *JESTER*, *HORN
DANCER*, *Abbots Bromley Horn Dance*,
Staffordshire

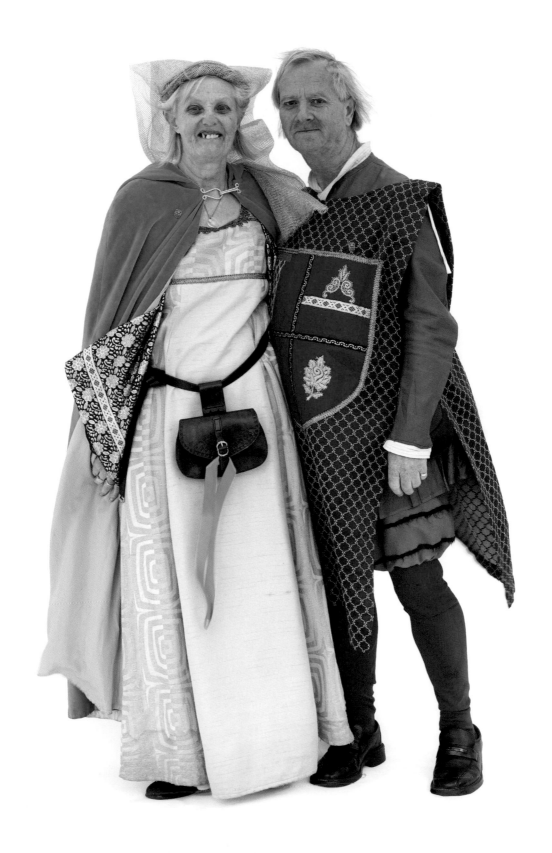

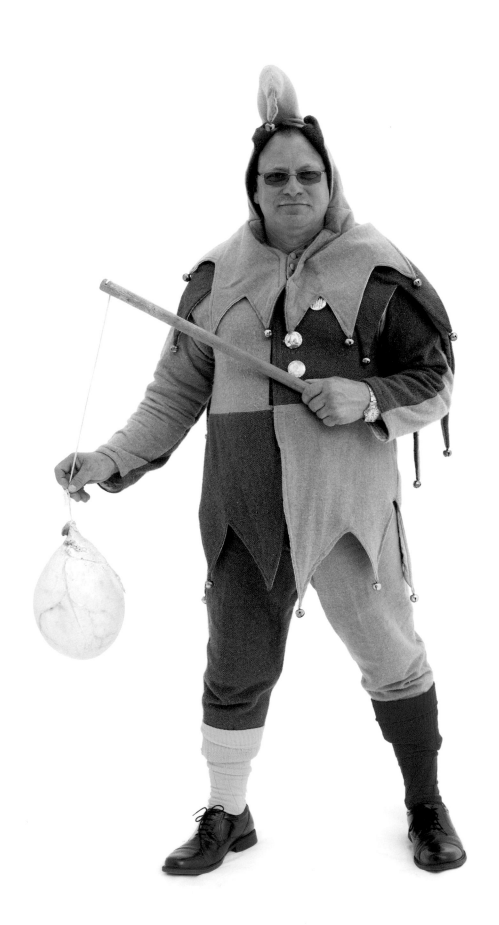

Jonny Feasey, *MAID MARIAN*, *HORN DANCER*, Abbots Bromley Horn Dance, Staffordshire

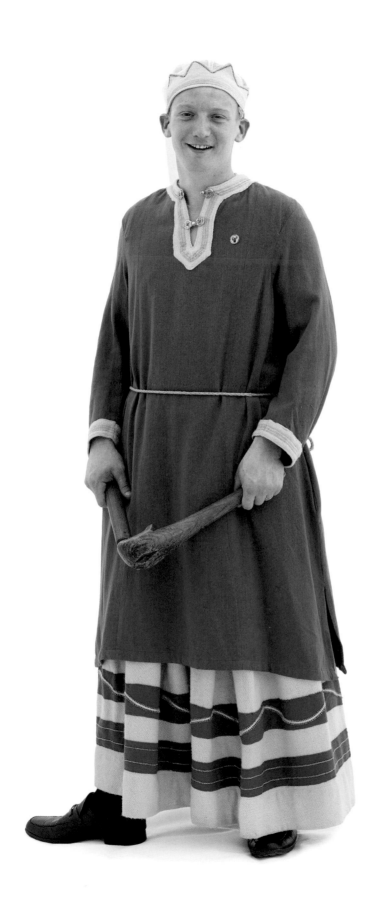

Richard, *Abbots Bromley Horn Dance*,
Staffordshire

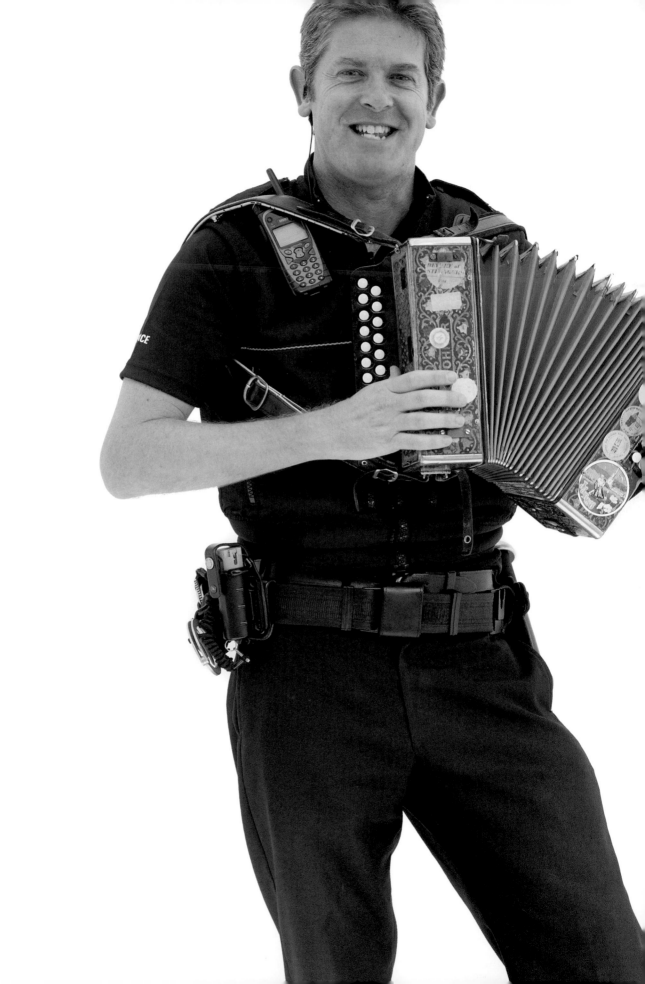

Daniel Pickering, *ARCHER*, *HORN DANCER*, *Abbots Bromley Horn Dance*, Staffordshire

OVERLEAF
LEFT Jamic Bradbury, *HORN DANCER*, *Abbots Bromley Horn Dance*, Staffordshire

RIGHT Jeff Bradbury, *HORN DANCER*, *Abbots Bromley Horn Dance*, Staffordshire

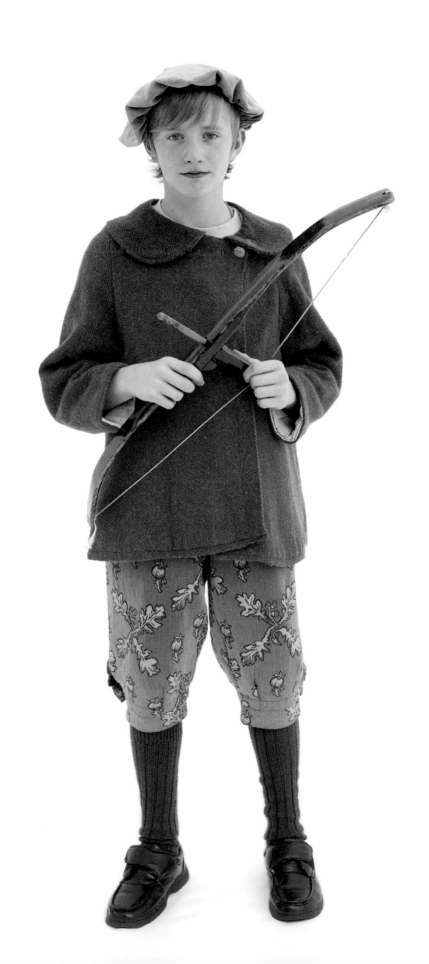

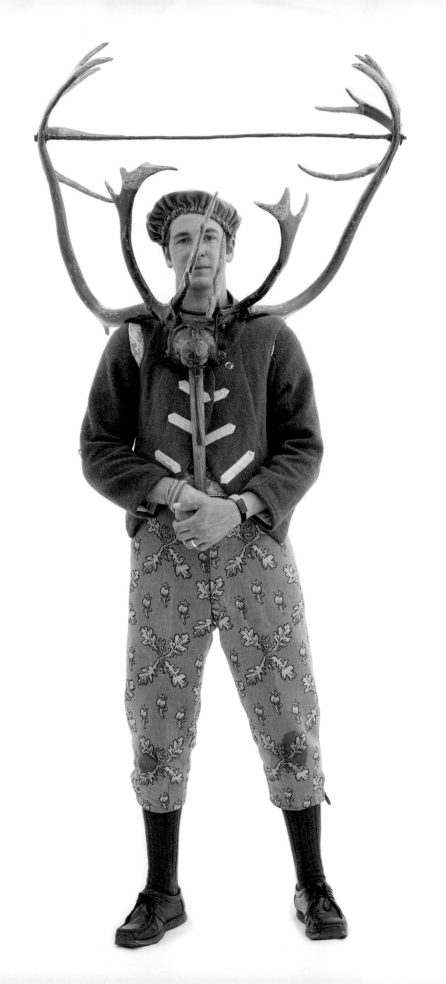

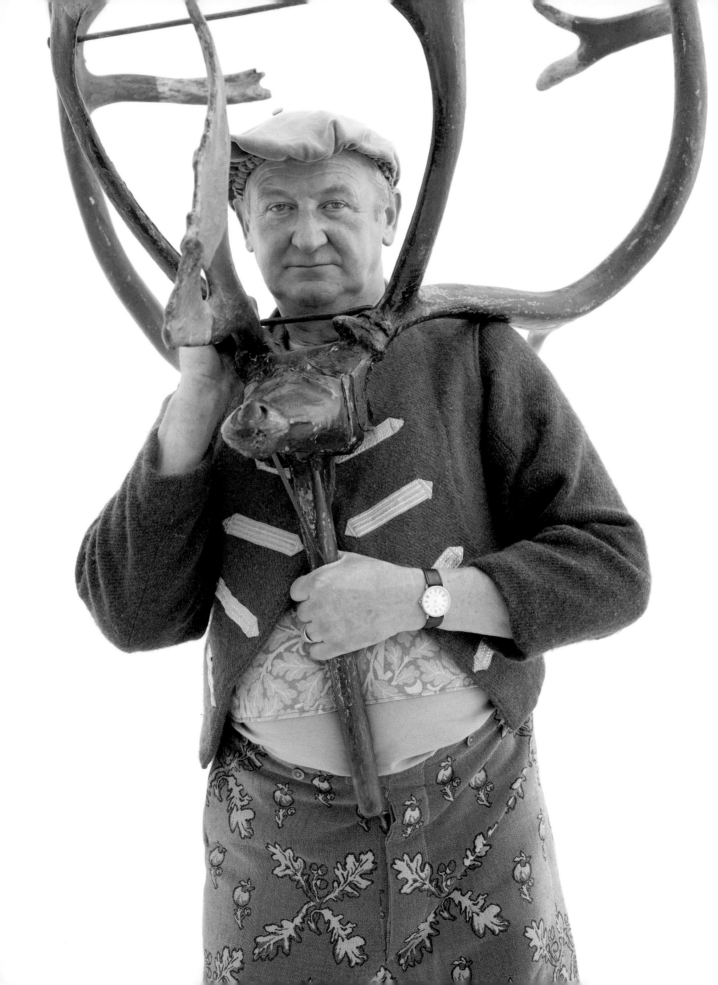

Joe Bailey, *HORN DANCER*, *Abbots*
Bromley Horn Dance, Staffordshire

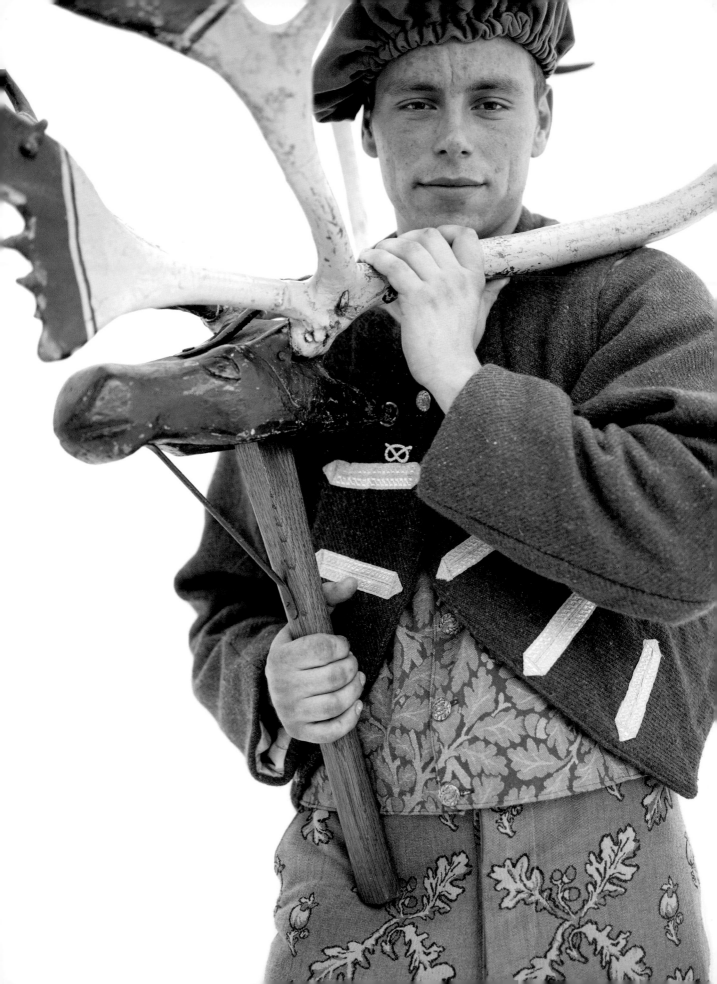

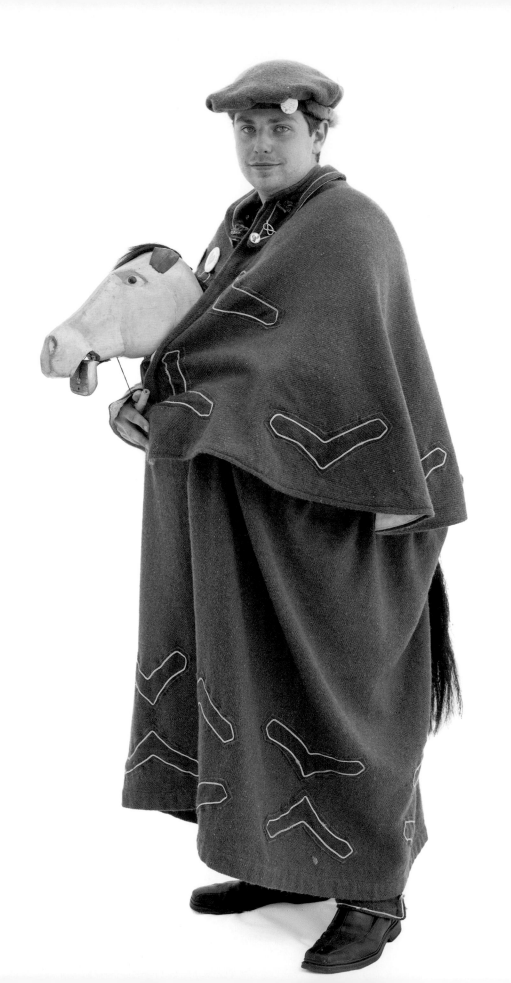

David Sweeting, *HOBBY HORSE*, *Abbots Bromley Horn Dance*, Staffordshire

OVERLEAF

LEFT Maggie Lloyd Davis, *RAVEN*, *HIGH PRIESTESS IN THE CRAFT*, Southampton, Hampshire

RIGHT Jan (Pixi), *BRIDJET*, *HIGH PRIESTESS IN THE CRAFT AND TEACHER*, Southampton, Hampshire

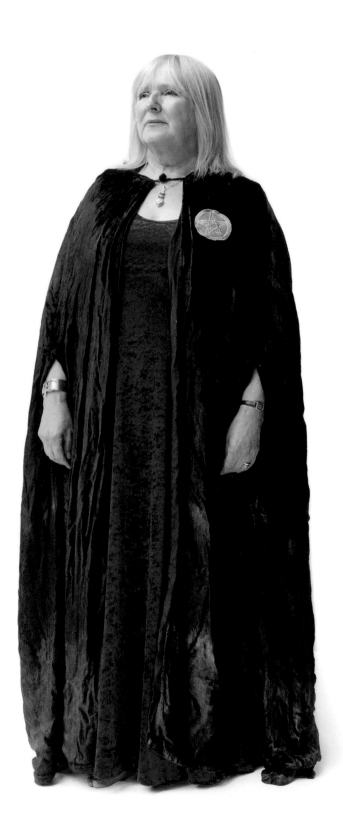

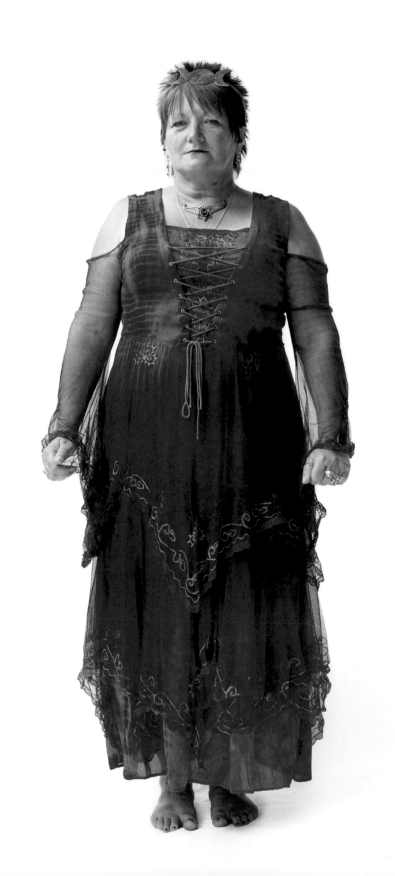

John, *HIGH PRIEST IN THE CRAFT AND TEACHER*, Southampton, Hampshire

OVERLEAF
LEFT Ron, *SILVEREAGLE SPIRIT, PRIEST IN THE CRAFT AND TEACHER*, Southampton, Hampshire

RIGHT Maureen Wheeler, *ORDAINED PRIESTESS OF ISIS, PRIESTESS AND ELDER IN THE CRAFT*, Southampton, Hampshire

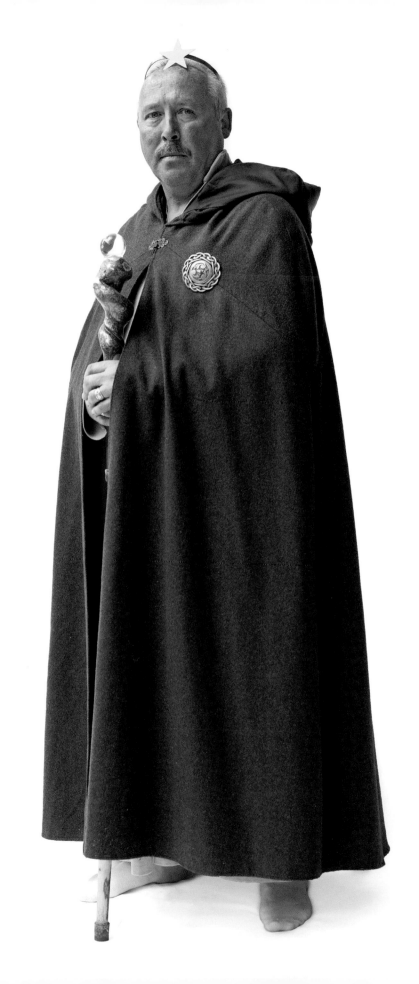

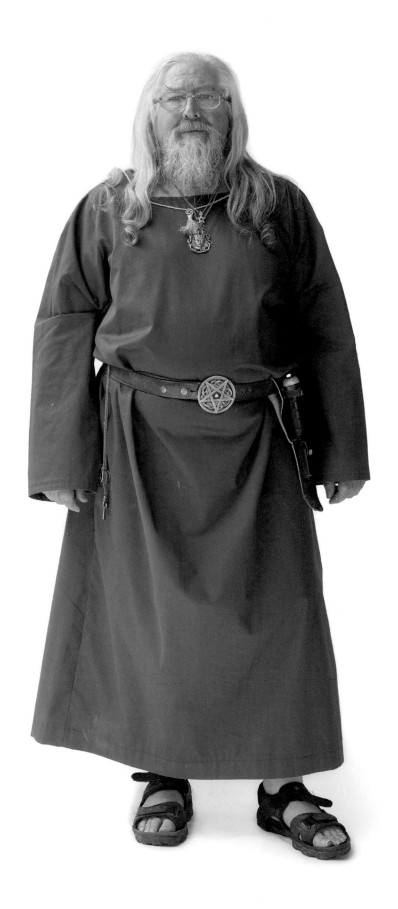

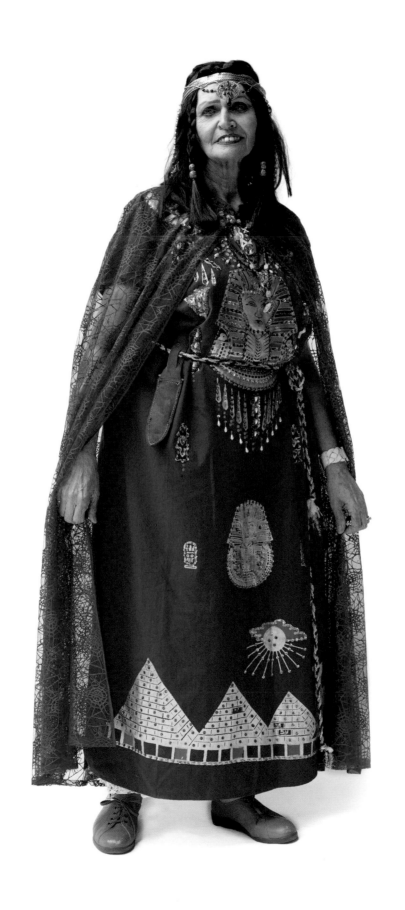

Martin McNulty (warehouse man)
and Gavin McNulty (disc jockey),
BRITANNIA COCO-NUT DANCERS,
Bacup, Lancashire

OVERLEAF
LEFT Dick Shufflebottom (retired
roofer), *BRITANNIA COCO-NUT
DANCERS*, Bacup, Lancashire

RIGHT Joe Healey (retired scutcher),
BRITANNIA COCO-NUT DANCERS,
Bacup, Lancashire

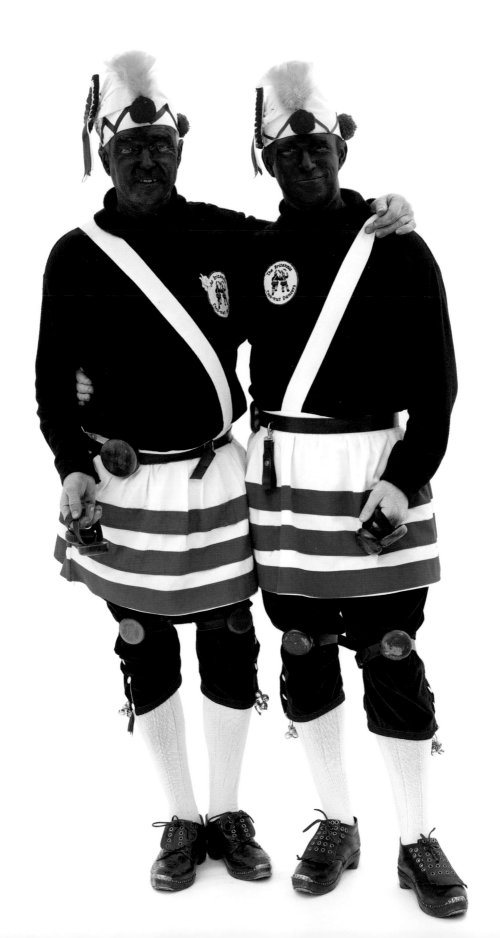

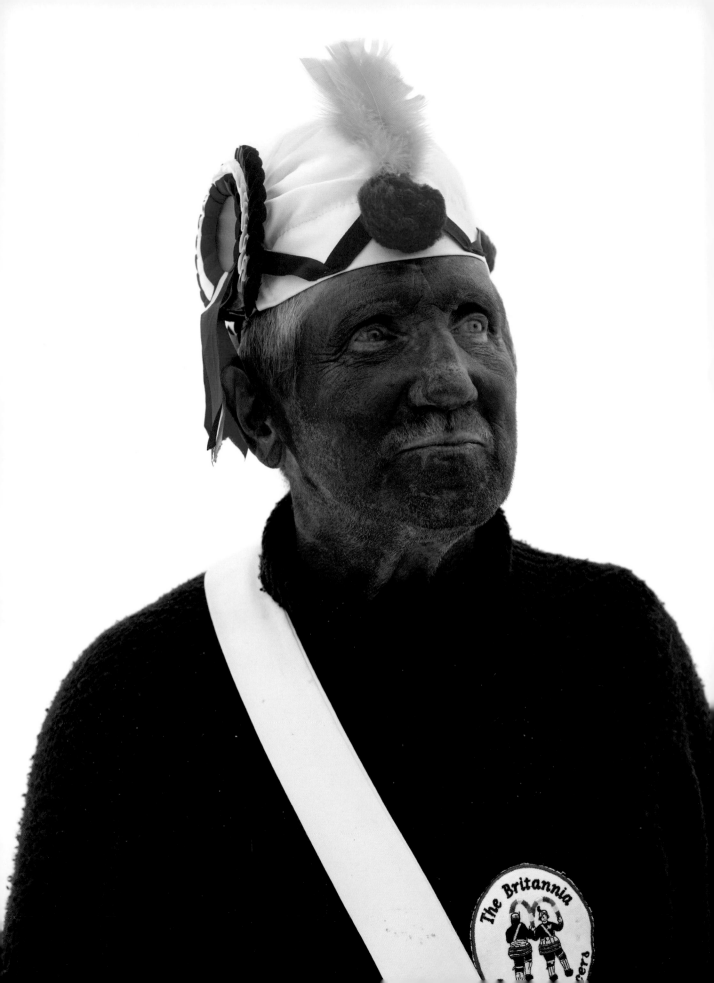

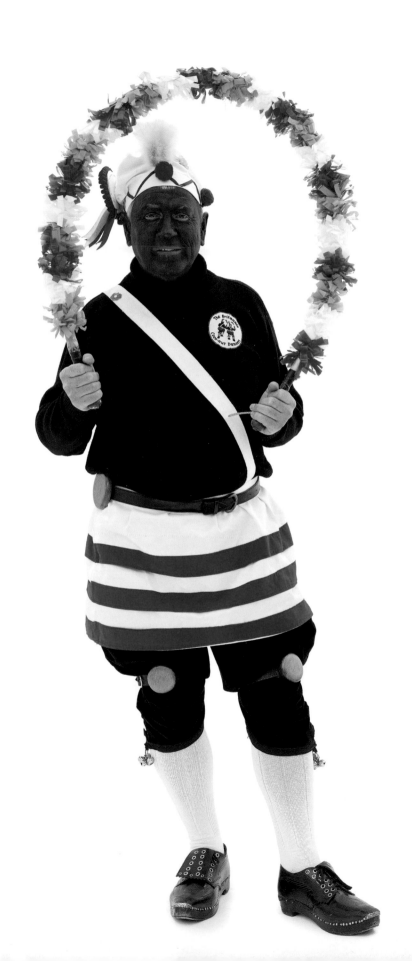

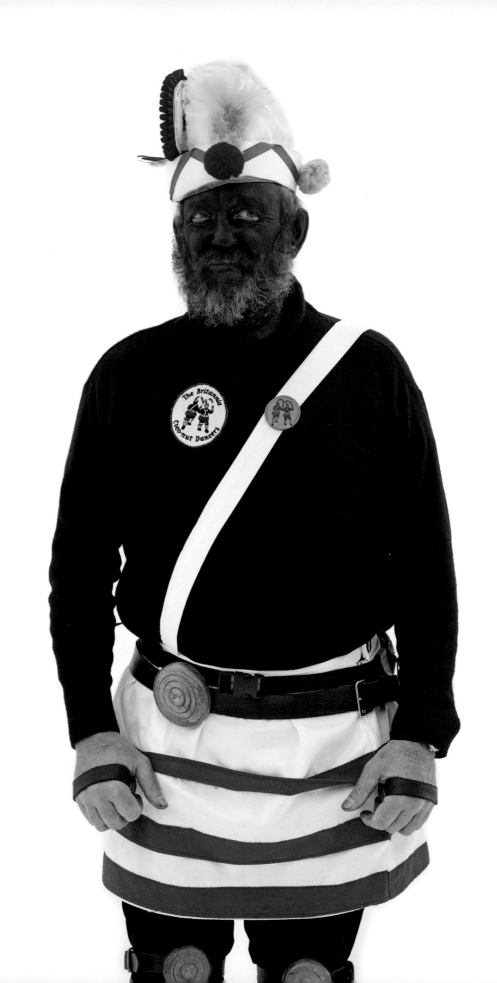

Neville Earnshaw (retired fire officer),
BRITANNIA COCO-NUT DANCERS,
Bacup, Lancashire

John Izod, *Bonfire Night*,
Hastings, East Sussex

OVERLEAF
LEFT Geoff Isted, *Bonfire Night*,
Hastings, East Sussex

RIGHT Graham Georges
(photographer), *Bonfire Night*,
Hastings, East Sussex

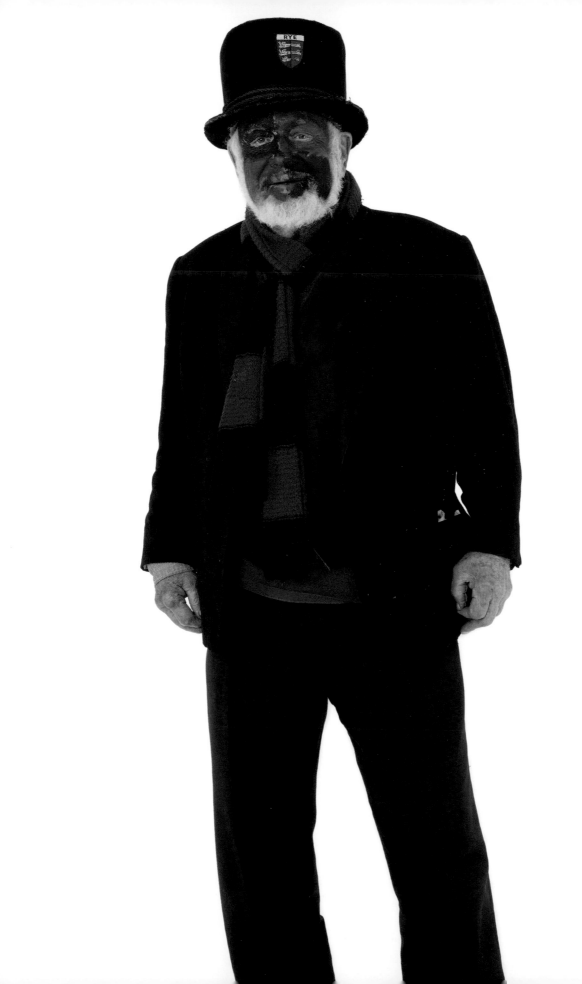

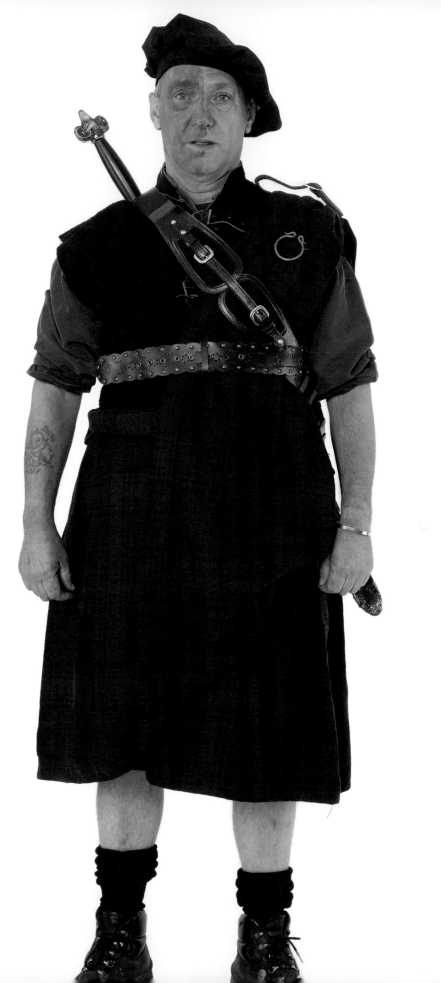

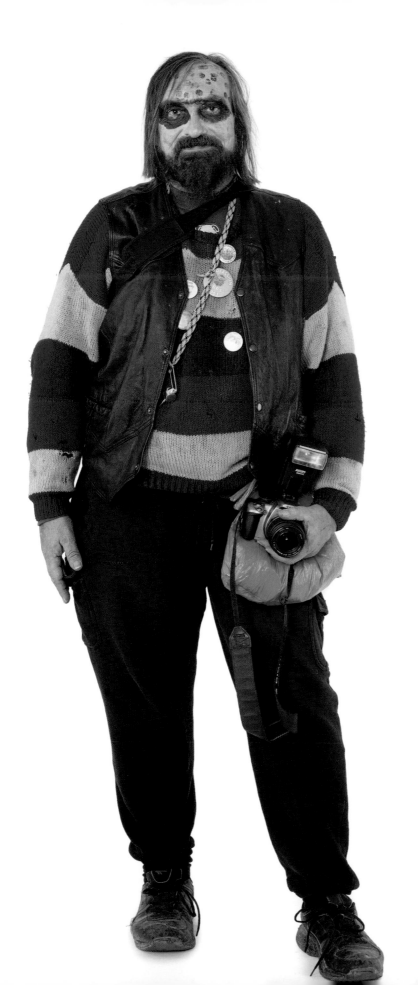

David Gray, *MOLLIE, HOODENER,*
Hoodening, St Nicholas-at-Wade, Kent

OVERLEAF, LEFT AND RIGHT
Ben Jones (Japanese translator),
GEORGE, HOODENER, *Hoodening*,
St Nicholas-at-Wade, Kent

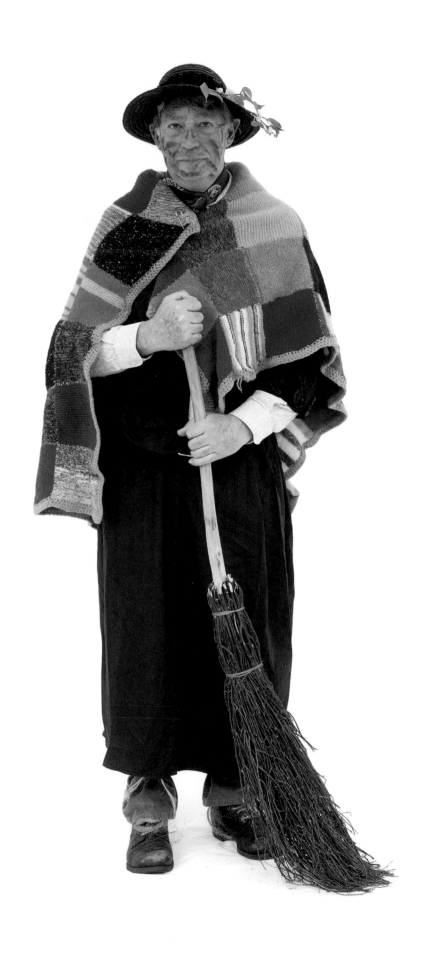

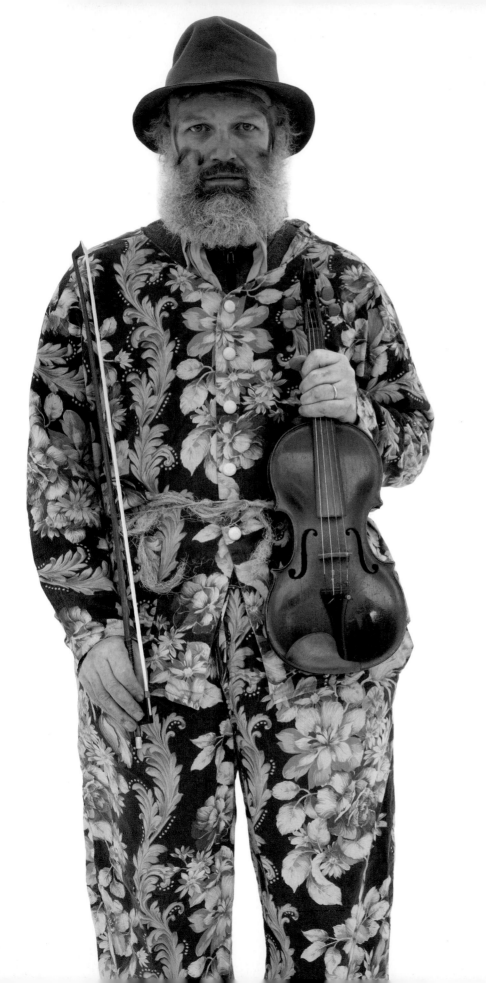

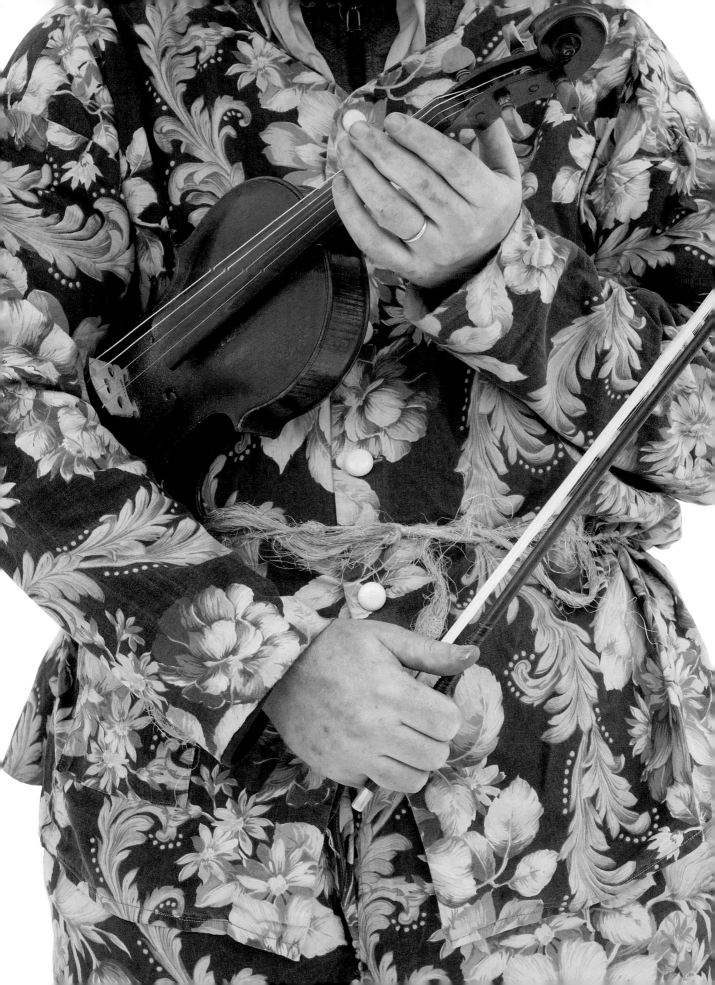

Peter Paul, *BILL, WAGONER*, and
Simon Lane, *'ORSE (DOBBIN)*,
Hoodening, St Nicholas-at-Wade, Kent

OVERLEAF
LEFT Simon Lane, *'ORSE* (also
known as *BLACK BEAUTY* or *SATAN*),
Hoodening, St Nicholas-at-Wade, Kent

RIGHT Jake, *Jack-in-the-Green*,
Hastings, East Sussex

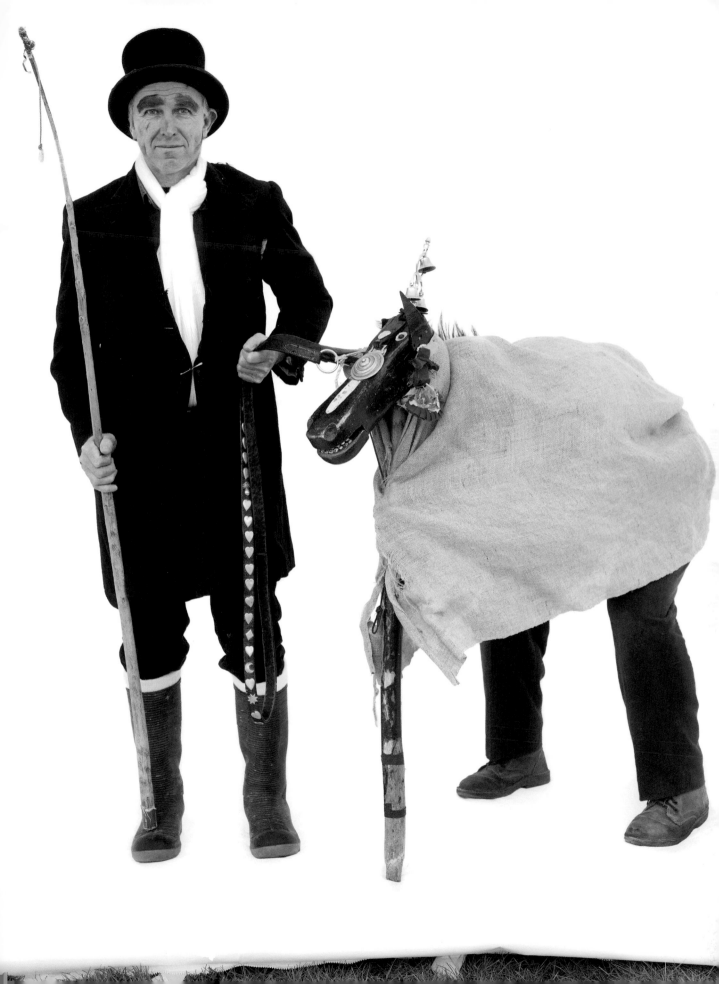

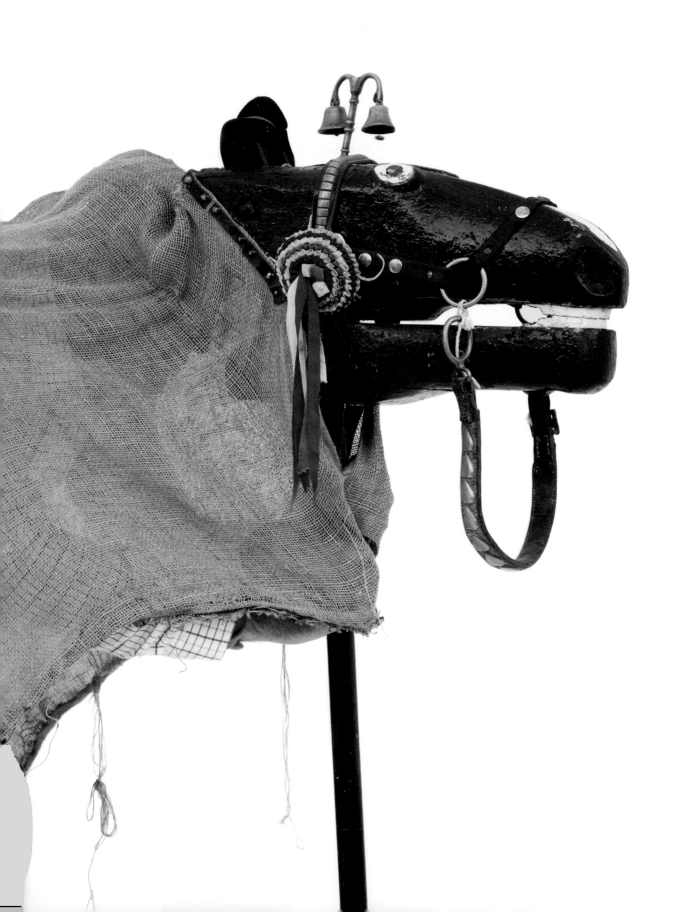

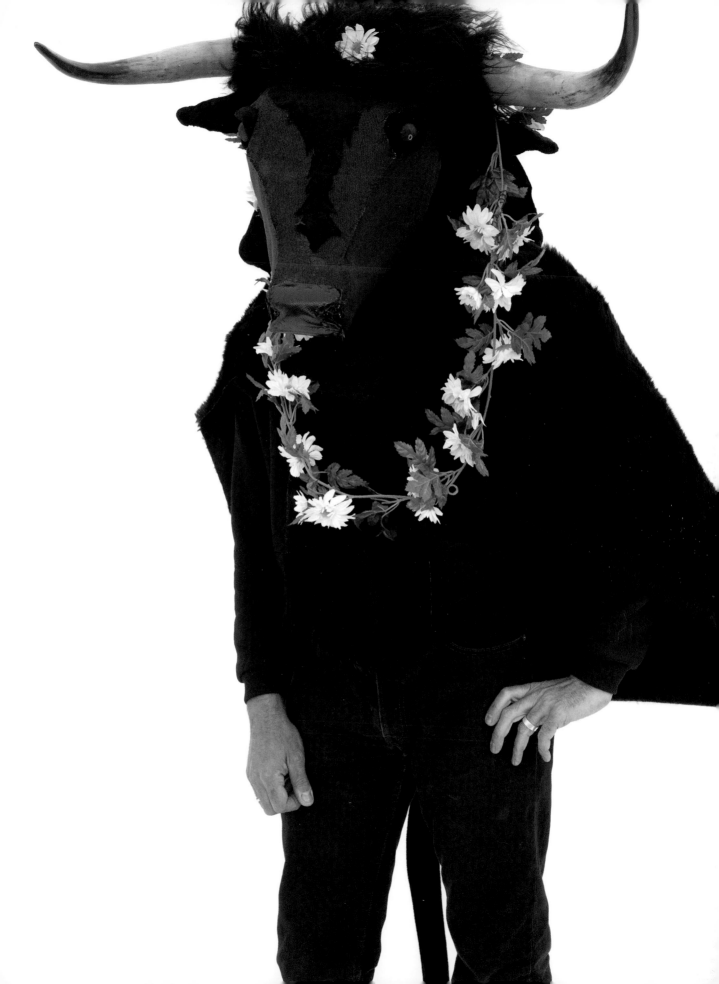

Romany Peg and her horse, Rhubarb,
Jack-in-the-Green, Hastings, East Sussex

OVERLEAF
LEFT Daniel Lane, *PIGSTY MORRIS*,
Wessex Folk Festival, Weymouth, Dorset

RIGHT Sarah Romp, *MAYFLOWER
MORRIS*, *Wessex Folk Festival*,
Weymouth, Dorset

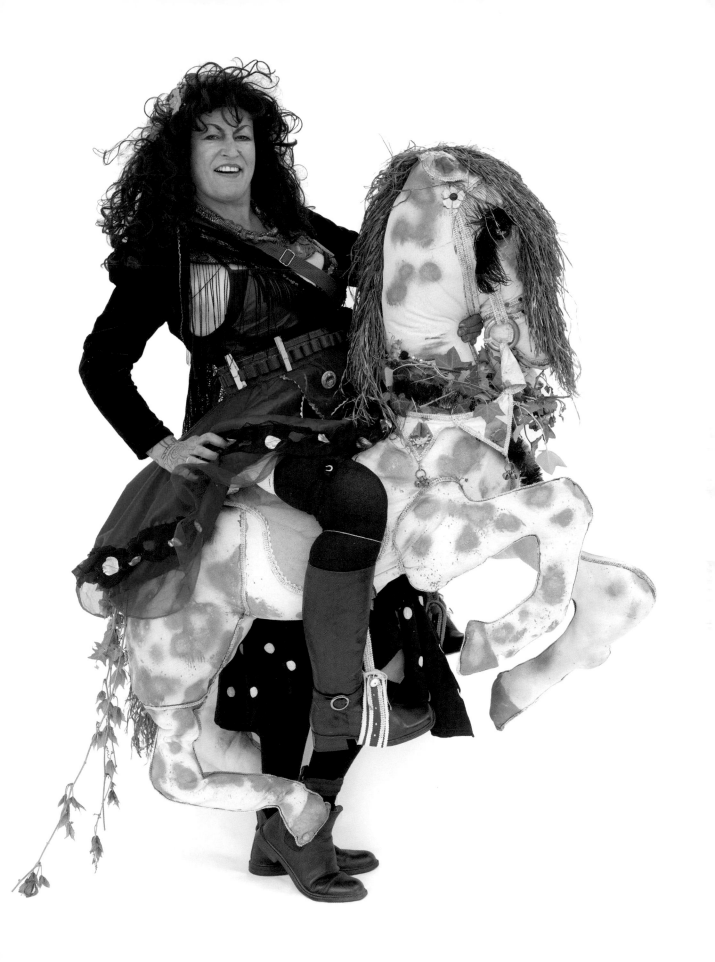

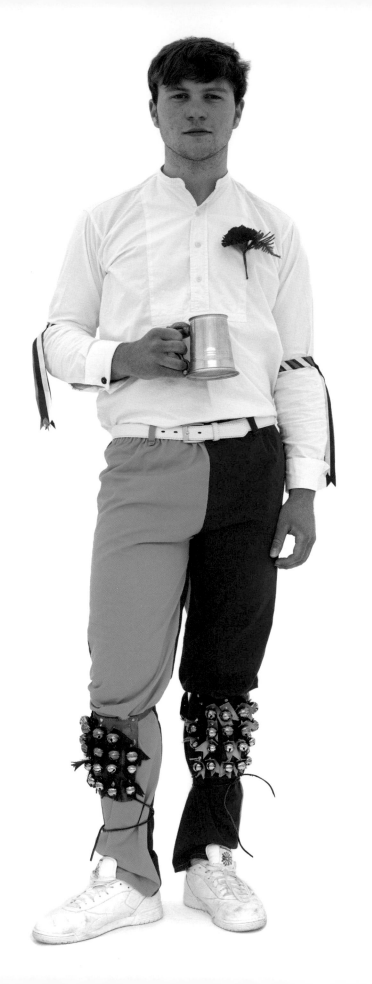

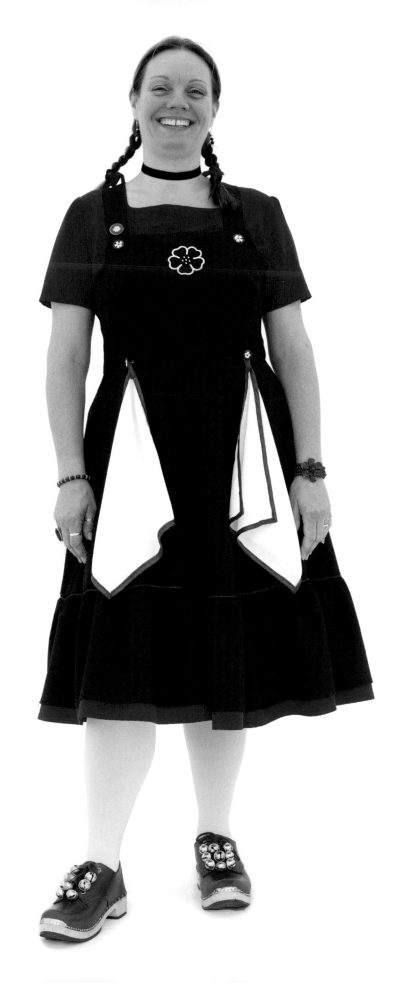

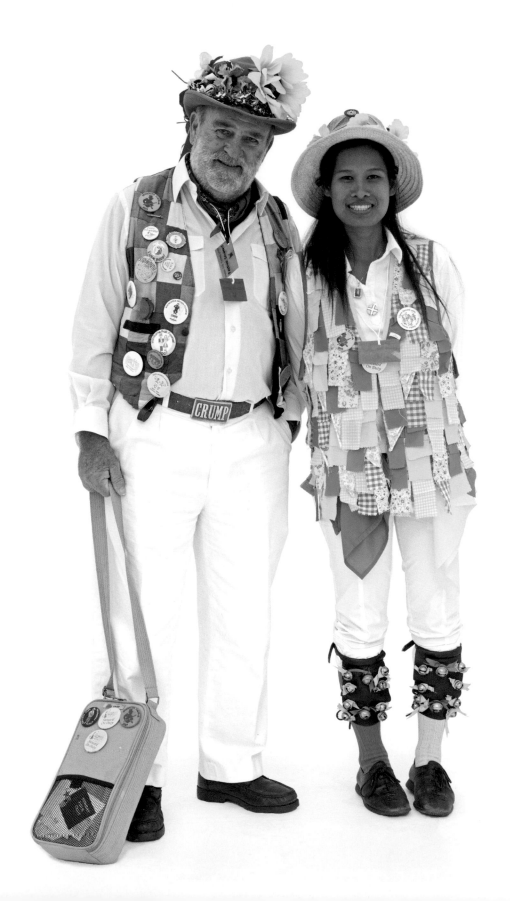

Bill and Hkeson, *FESTUS DERRIMAN MORRIS*, *Wessex Folk Festival*, Weymouth, Dorset

Kay Miller, *FLEUR DE LYS MORRIS, GODALMING, Wessex Folk Festival,* Weymouth, Dorset

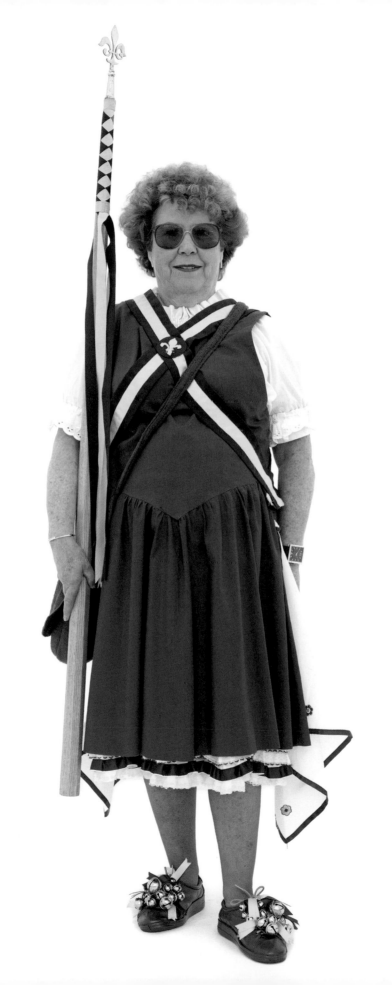

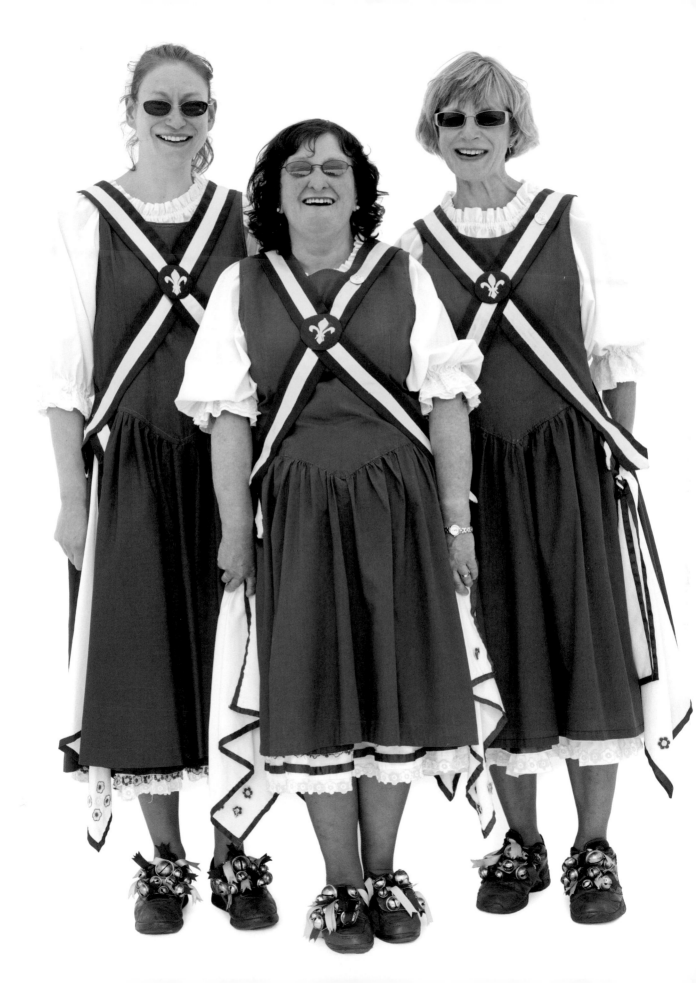

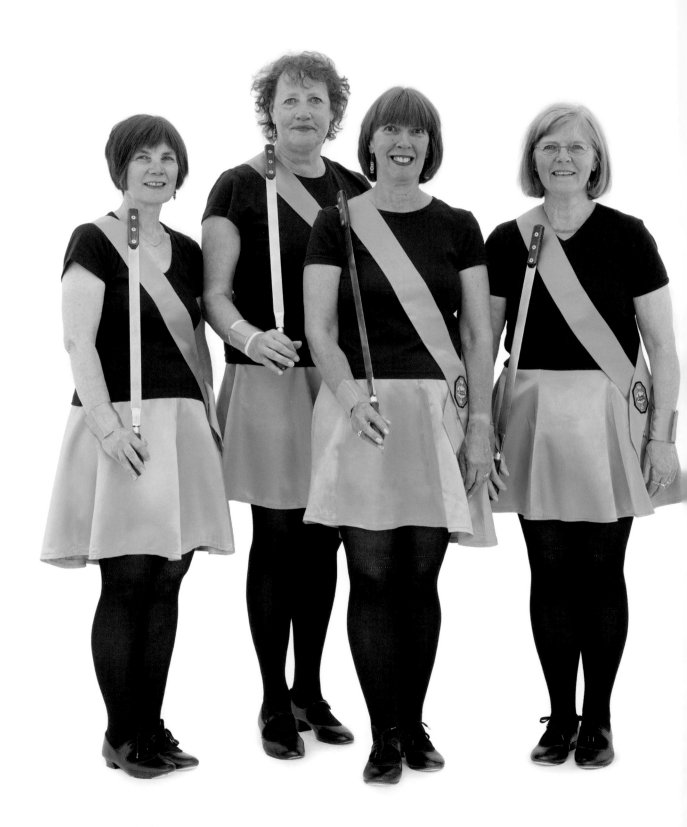

Barbara Wescott, Angie Fisher, Brigid
Dallow and Ursula Cox, *SWEET
RAPPERS (SWORD DANCERS)*, *Wessex
Folk Festival*, Weymouth, Dorset

OVERLEAF
LEFT Sam Ross and Colin Emmett,
PRISTON JUBILEE MORRIS, *Wessex
Folk Festival*, Weymouth, Dorset

RIGHT Richard Harris, *PRISTON
JUBILEE MORRIS*, *Wessex Folk Festival*,
Weymouth, Dorset

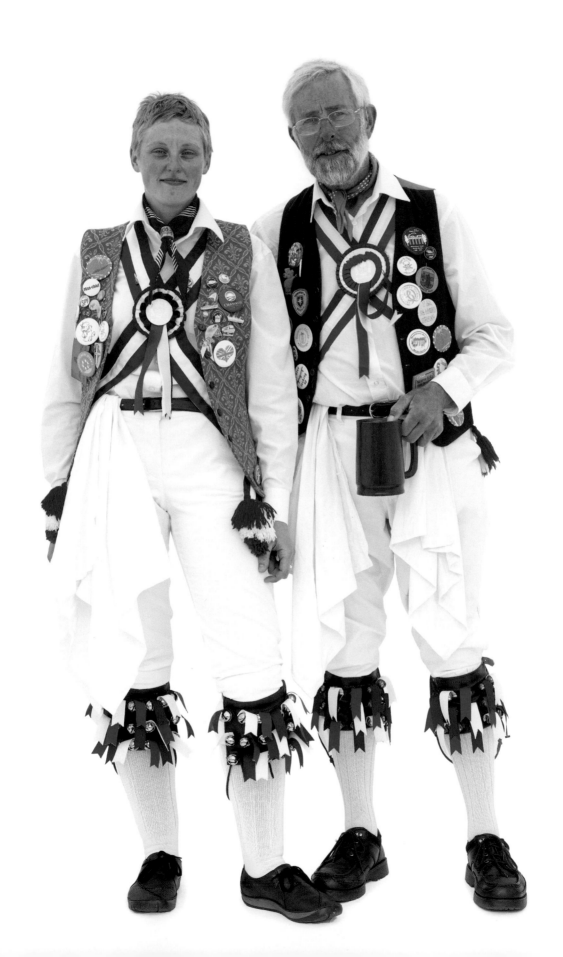

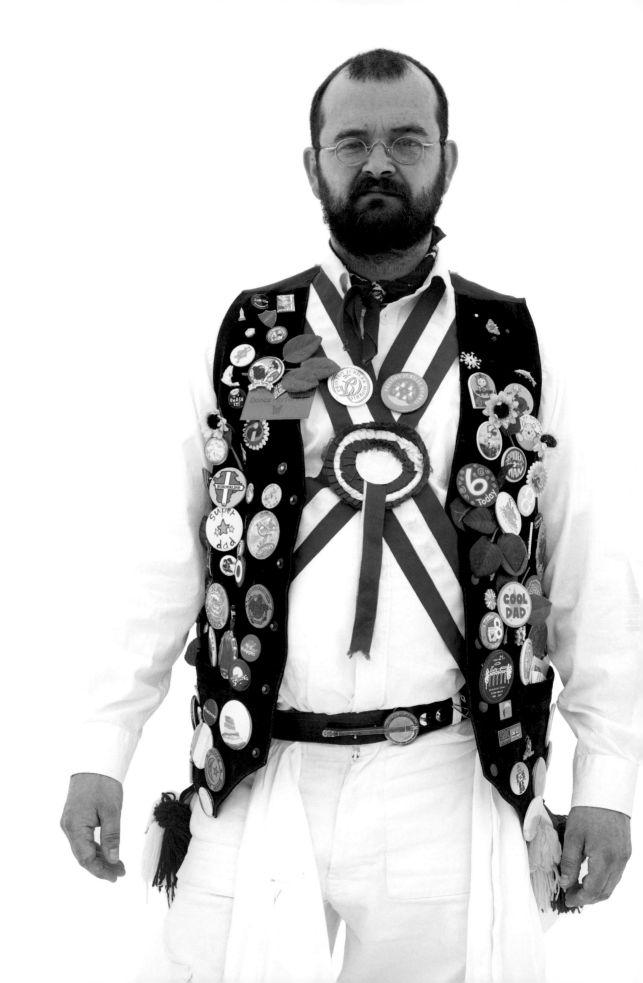

Doug Pattison, *PRISTON JUBILEE
MORRIS*, *Wessex Folk Festival*,
Weymouth, Dorset

OVERLEAF
LEFT Angy and Len Leggett, *FROME
VALLEY MORRIS*, *Wessex Folk Festival*,
Weymouth, Dorset

RIGHT Julie Matthews, Graham
Winter and Angela Burgess, *FROME
VALLEY MORRIS*, *Wessex Folk Festival*,
Weymouth, Dorset

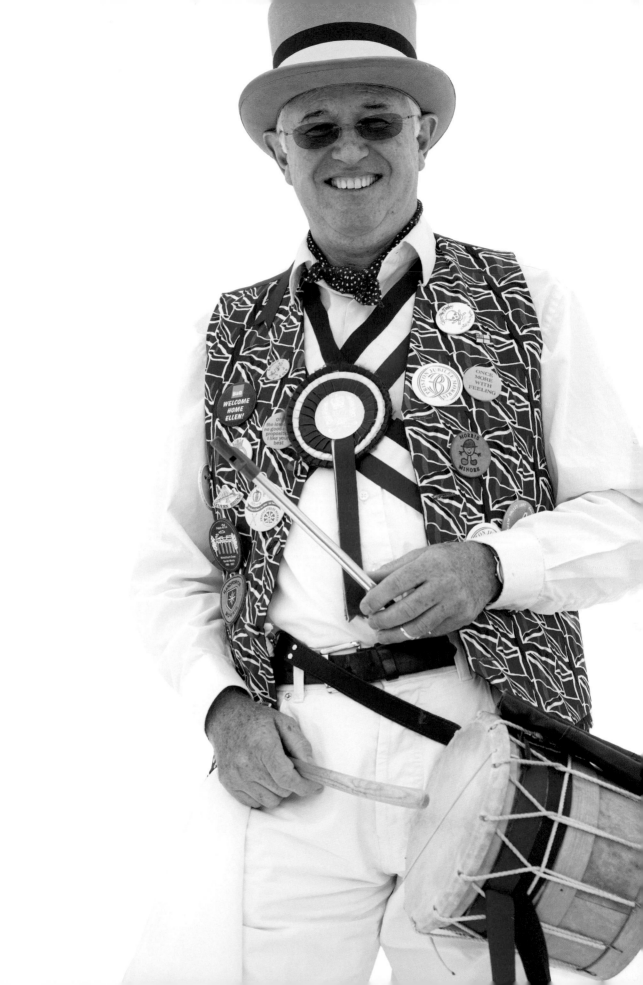

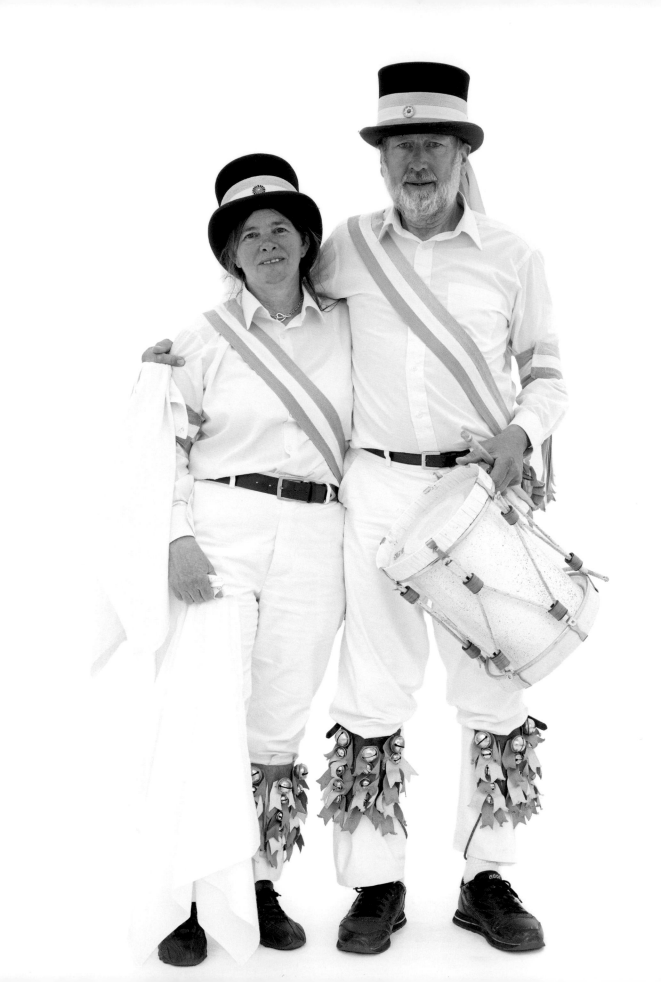

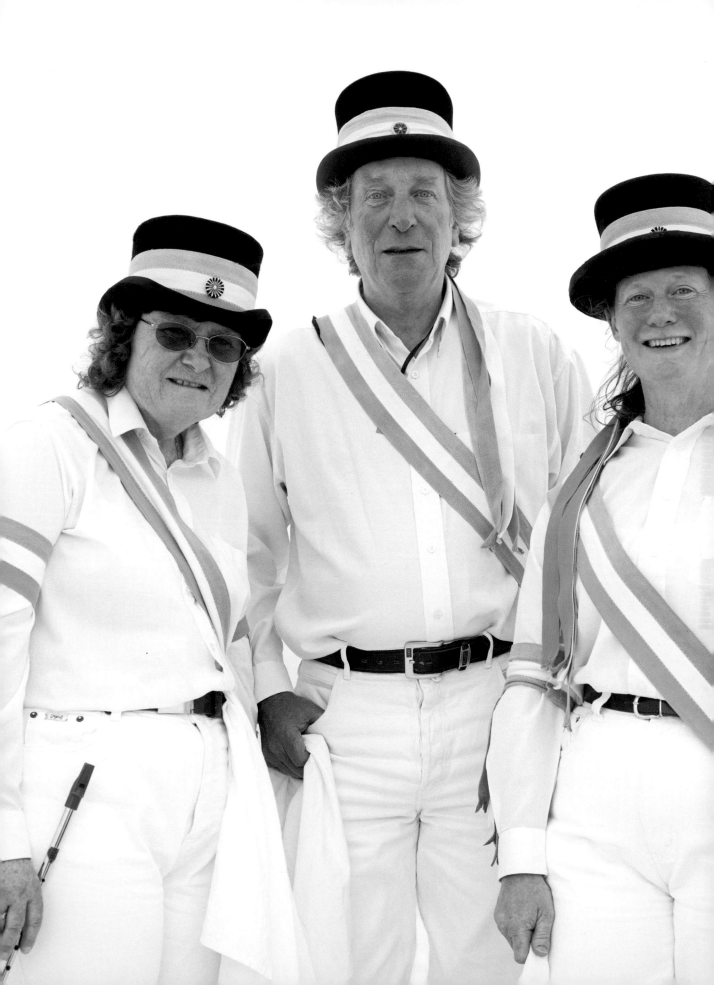

Gregg Rochfort, Debs Norman and
Simon Hewitt, *FROME VALLEY
MORRIS*, *Wessex Folk Festival*,
Weymouth, Dorset

OVERLEAF
LEFT Lynn Anderson,
BEETLECRUSHERS CLOG AND STEP,
Wessex Folk Festival, Weymouth, Dorset

RIGHT Jackie Freeman and Chris
English, *BEETLECRUSHERS CLOG AND
STEP*, *Wessex Folk Festival*, Weymouth,
Dorset

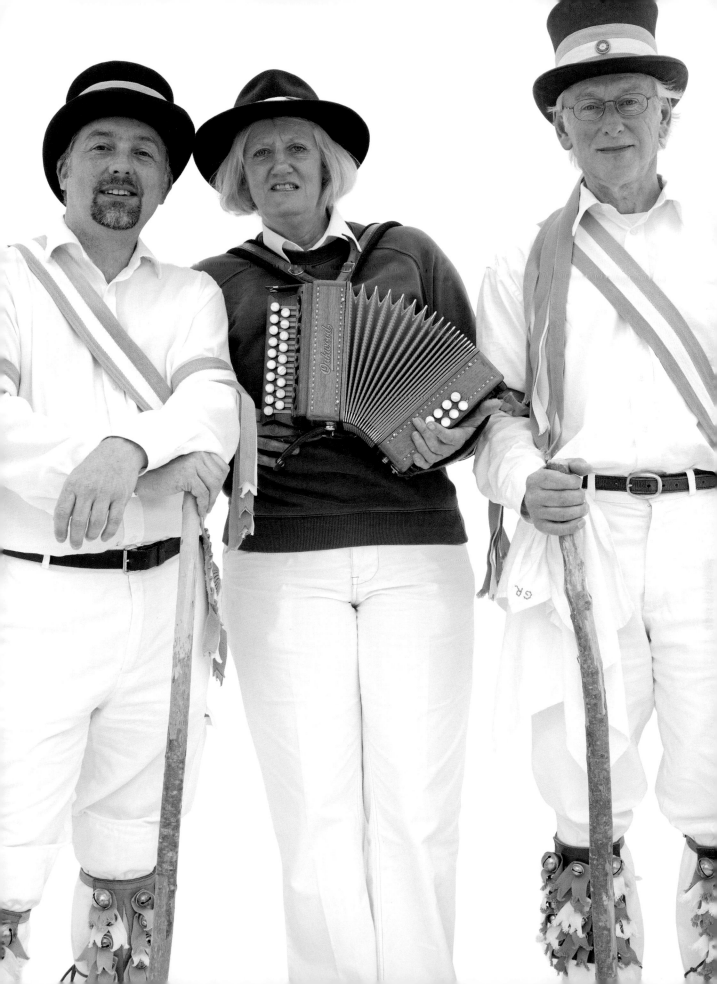

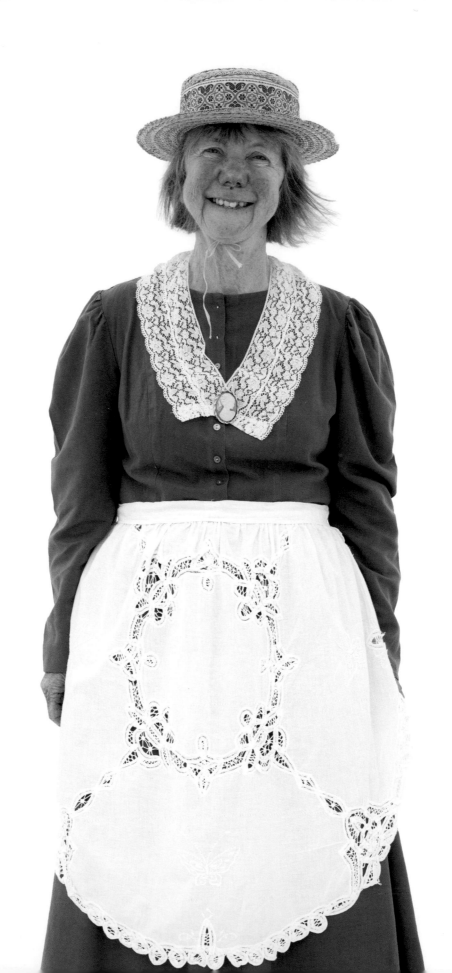

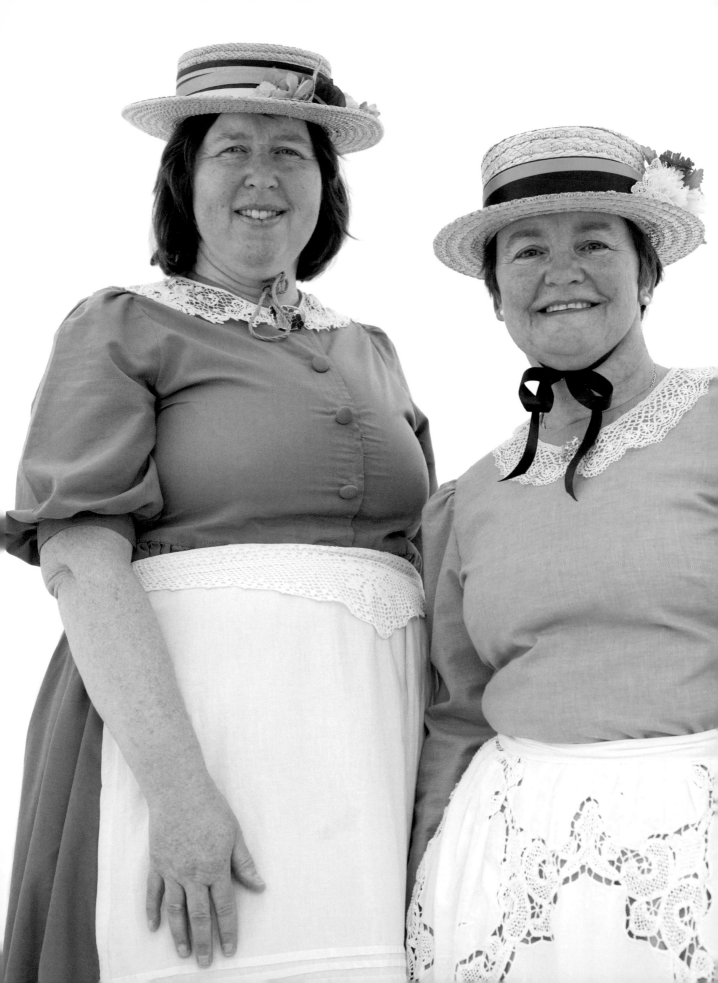

Louis Carver and Naziha Arebi,
Jack-in-the-Green, Hastings,
East Sussex

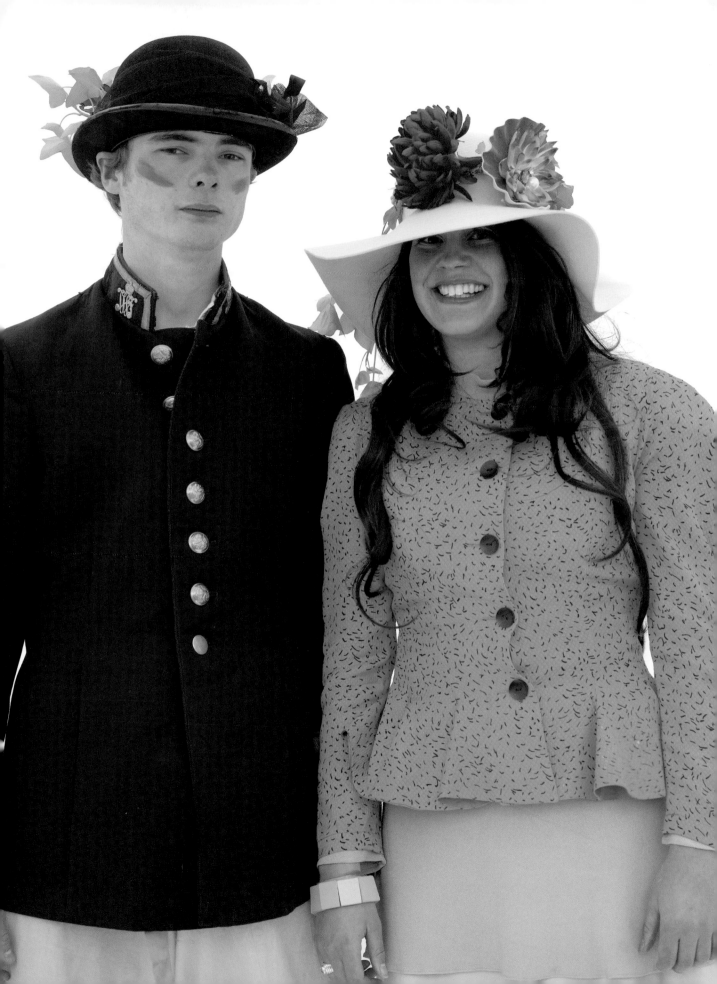

Trina Green and Jade Mitchell, *Jack-in-the-Green*, Hastings, East Sussex

OVERLEAF
LEFT Mavis Hewitt, *LODESTONE MORRIS*, *Wessex Folk Festival*, Weymouth, Dorset

RIGHT Pauline Ure, *ALTON MORRIS*, *Wessex Folk Festival*, Weymouth, Dorset

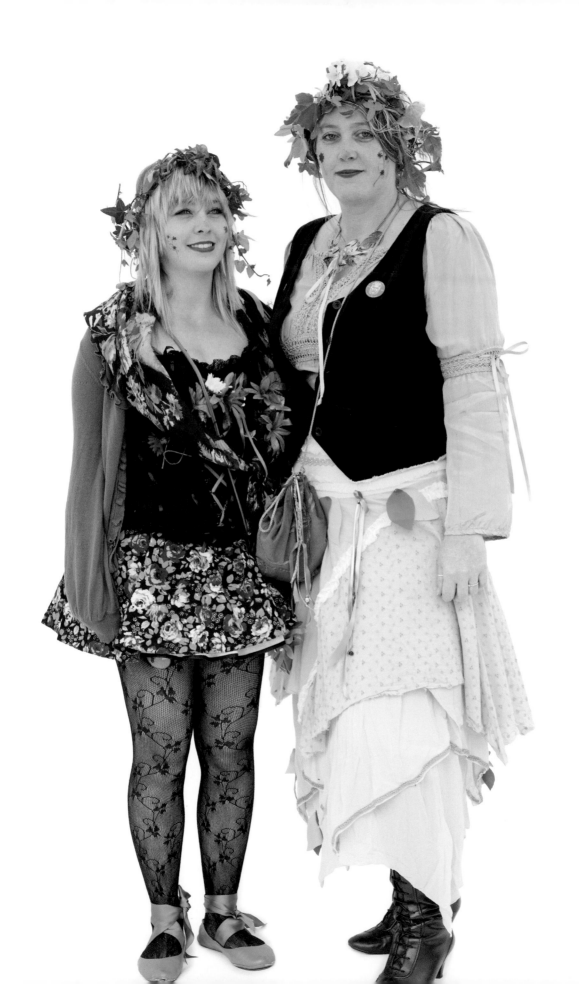

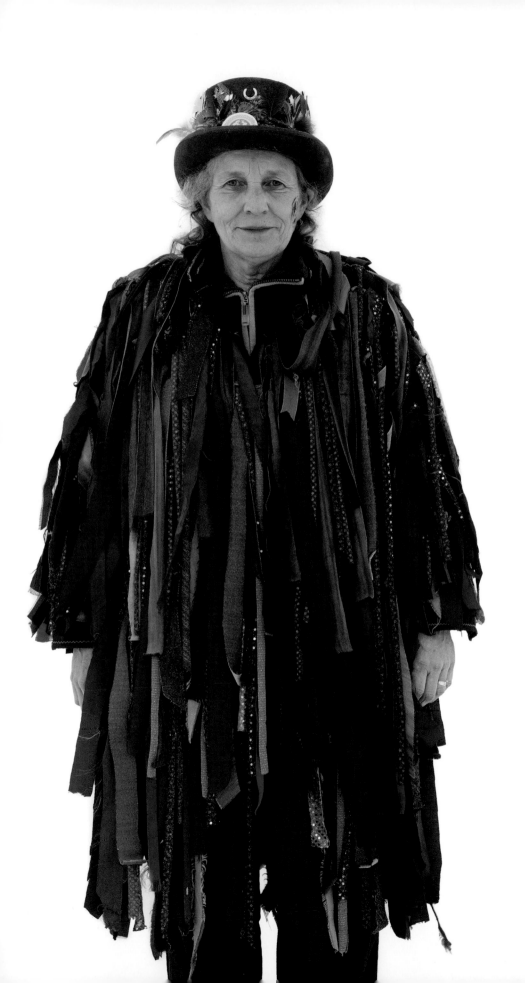

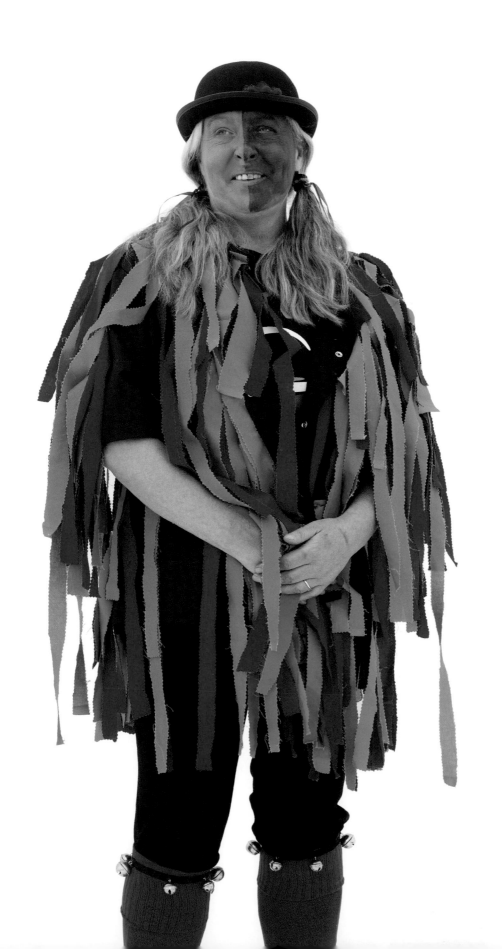

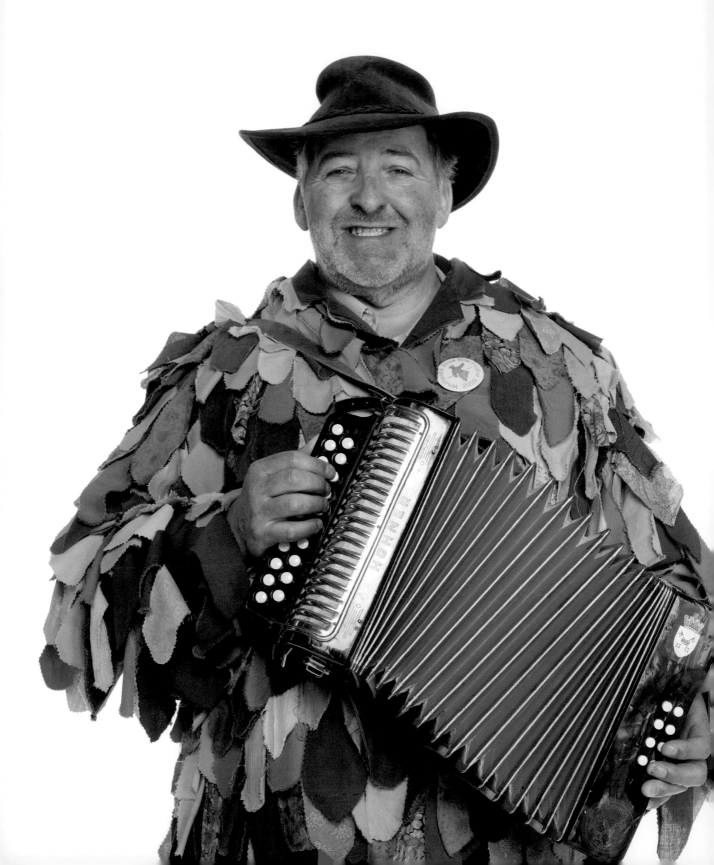

Pete Shaw, *Whittlesea Straw Bear Festival*, Whittlesey, Cambridgeshire

OVERLEAF
LEFT Johnathan Unna (chartered surveyor), *RUTLAND MORRIS*, *Whittlesea Straw Bear Festival*, Whittlesey, Cambridgeshire

RIGHT Sam the Drummer, *CLERICAL ERROR BORDER MORRIS*, *Jack-in-the-Green*, Hastings, East Sussex

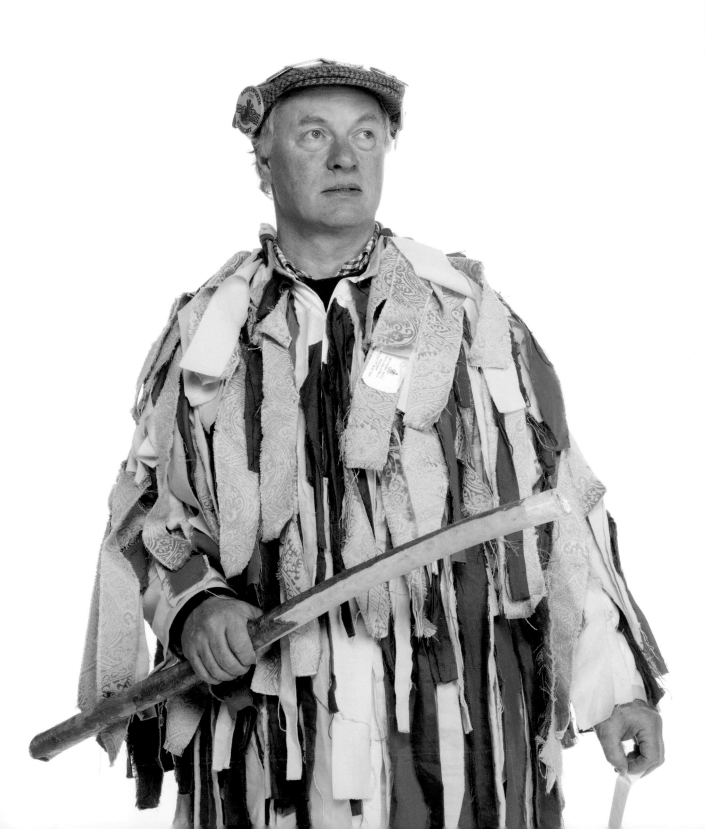

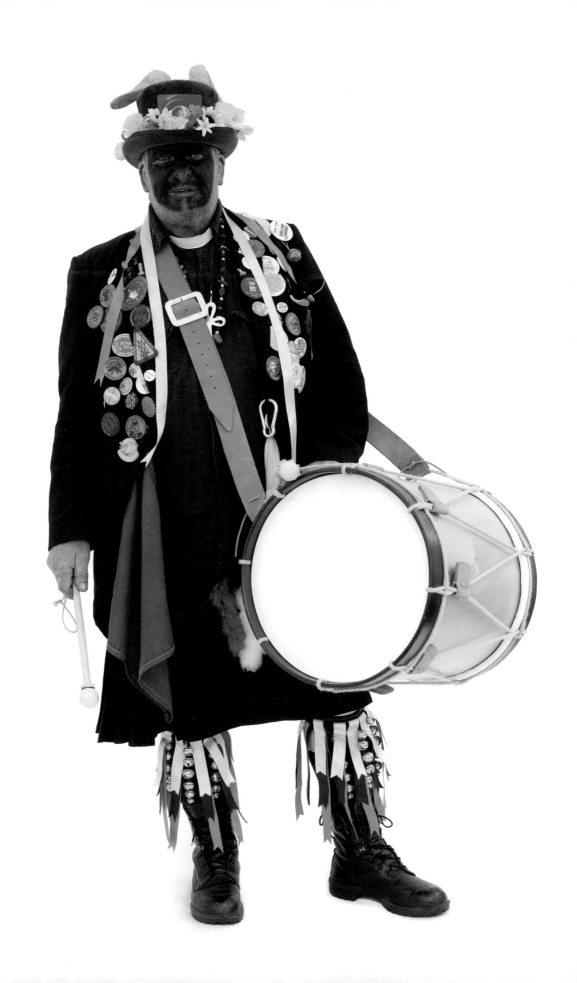

The Wicking family, *Jack-in-the-Green*,
Hastings, East Sussex

OVERLEAF
LEFT Marti Dean, *MARTIBOGIE*,
Jack-in-the-Green, Hastings, East
Sussex

RIGHT Keith Leech, *Jack-in-the-
Green*, Hastings, East Sussex

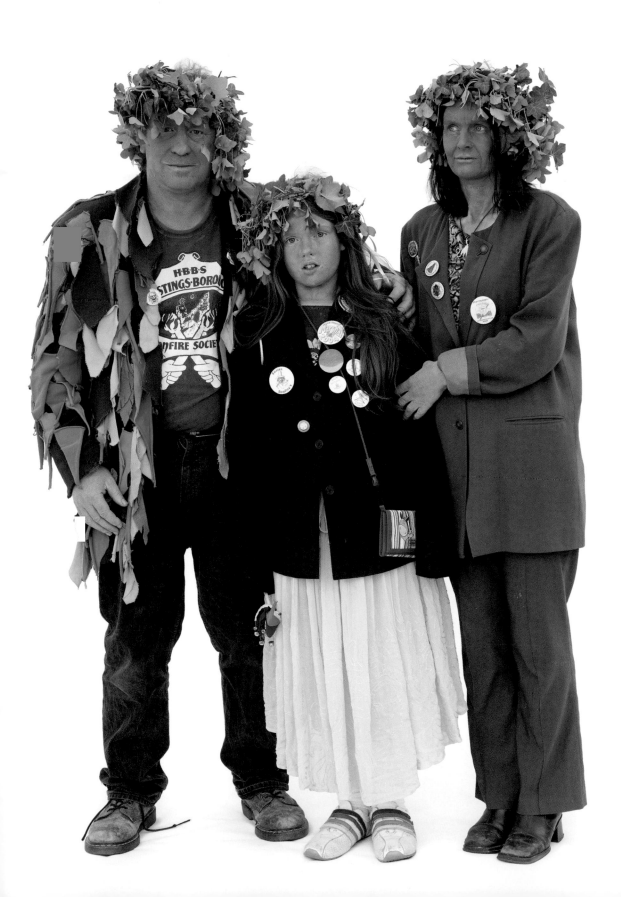

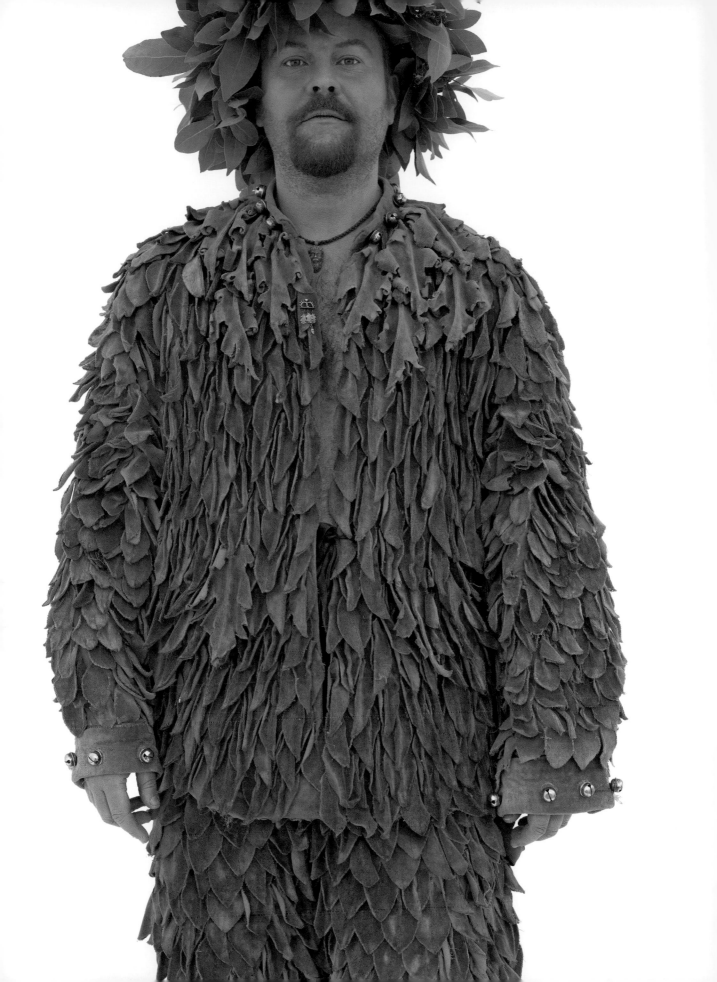

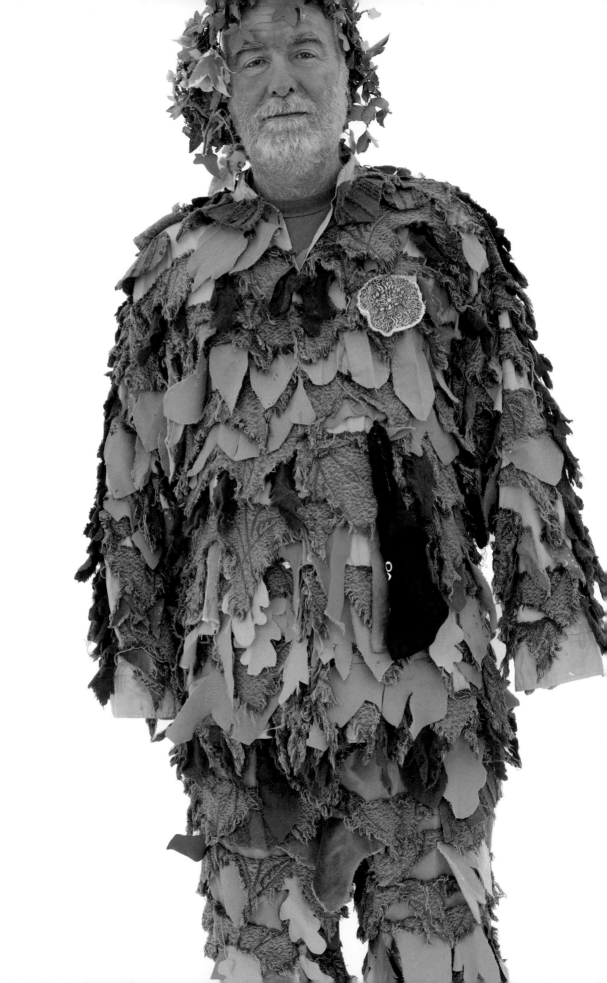

John Beaching, *Jack-in-the-Green*,
Hastings, East Sussex

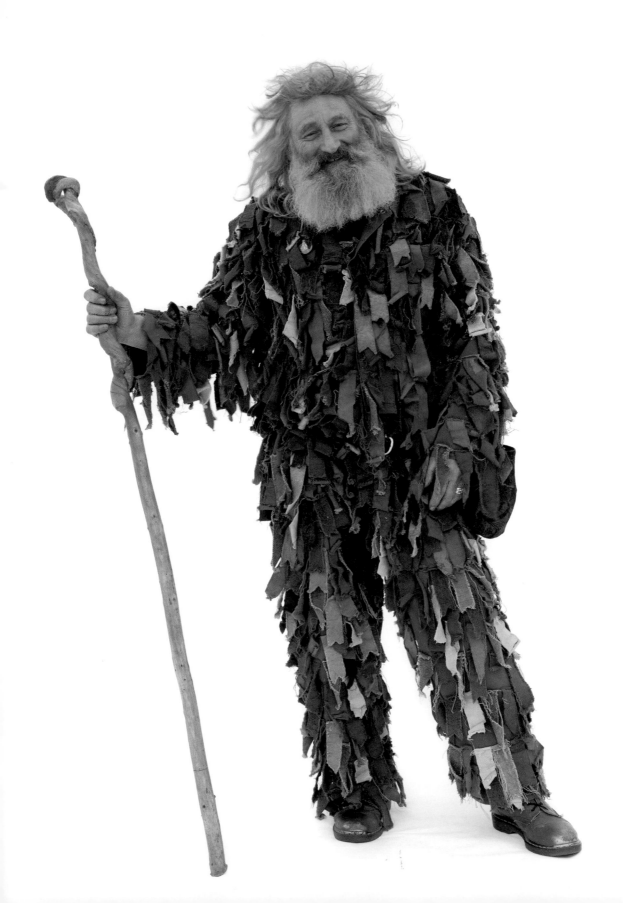

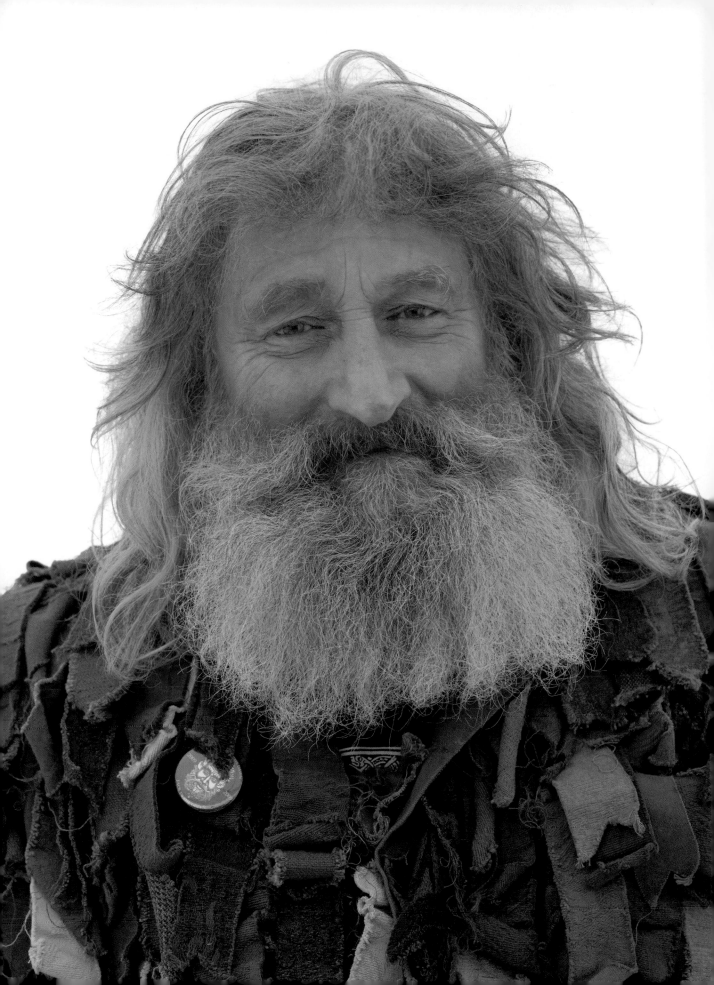

John Beaching, *Jack-in-the-Green*,
Hastings, East Sussex

OVERLEAF
LEFT Paddy, *Jack-in-the-Green*,
Hastings, East Sussex

RIGHT Gaby, *THE LOVELY LADIES*,
Jack-in-the-Green, Hastings, East Sussex

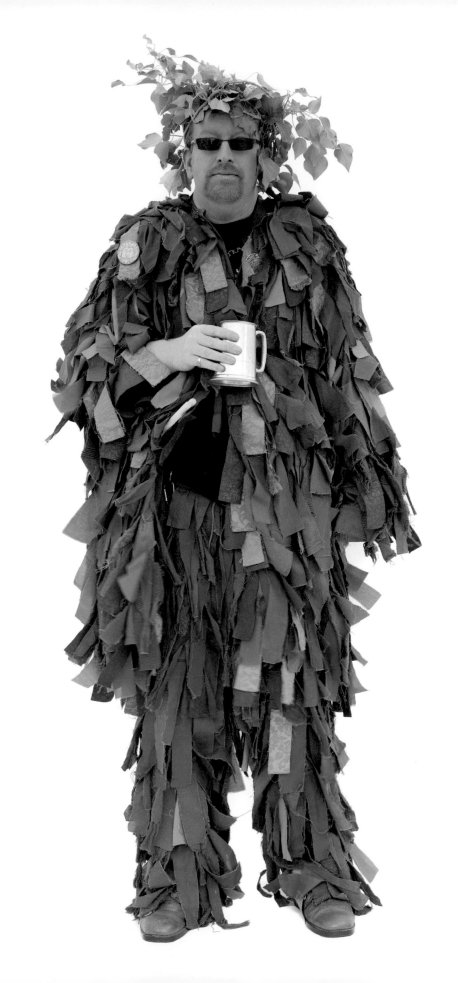

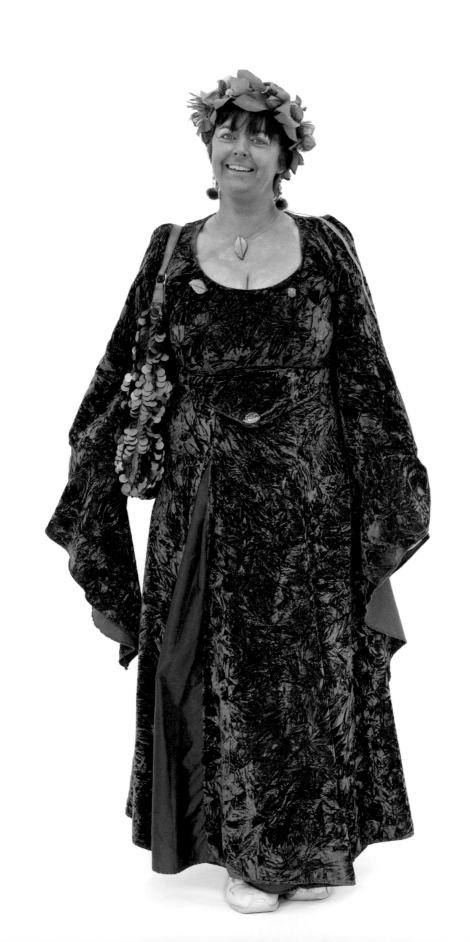

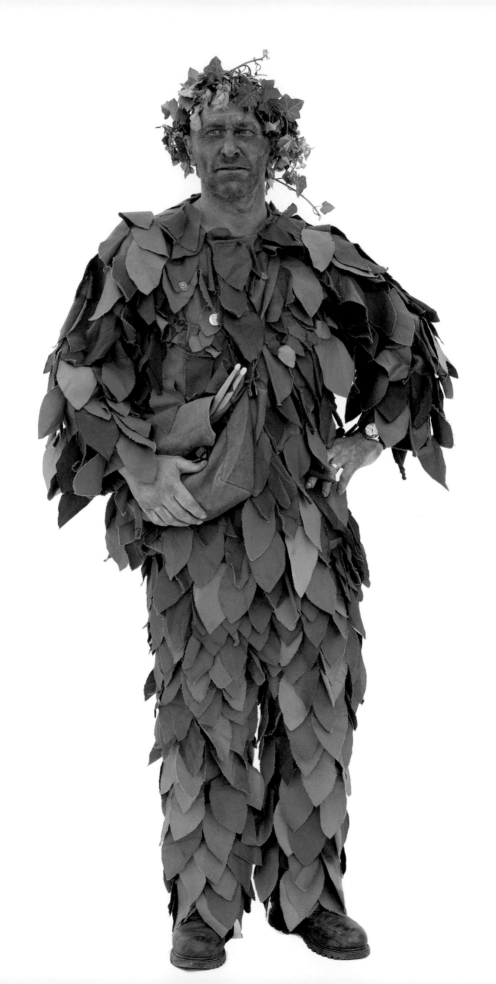

Bogie Spunky, *Jack in the Green*,
Hastings, East Sussex

OVERLEAF, LEFT AND RIGHT
Mike Faulkner, *LONG DISTANCE
GREEN MAN, CUMBRIA*, *Jack-in-the-
Green*, Hastings, East Sussex

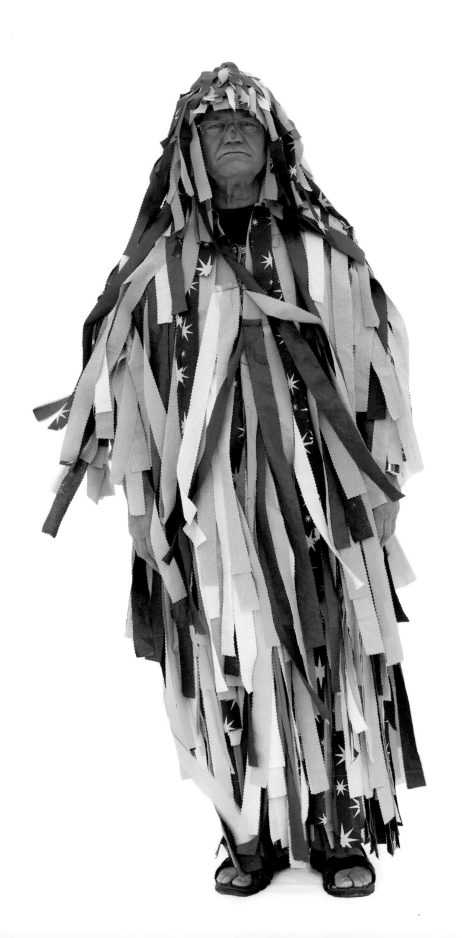

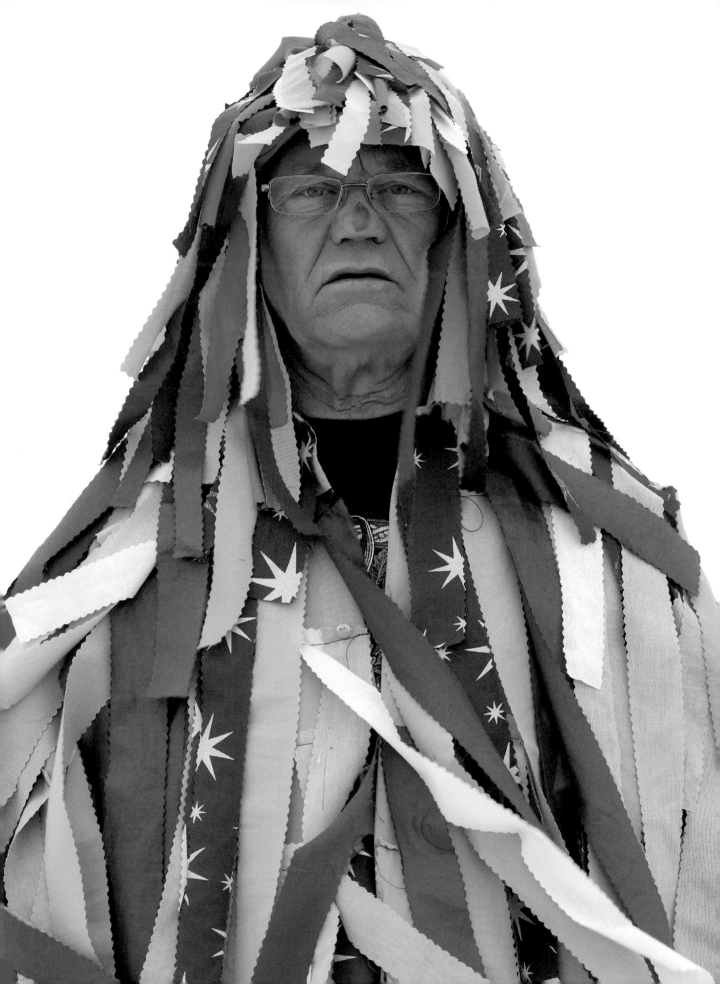

John Nicol (graphic designer), *THE BURRY MAN*, South Queensferry, Edinburgh, Scotland

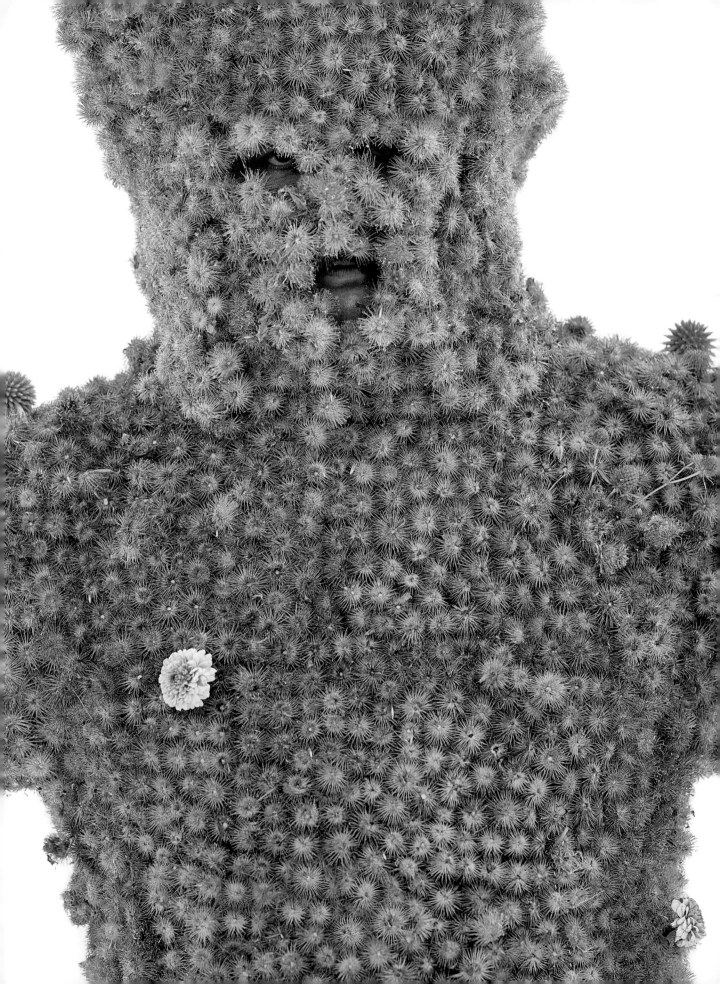

John Nicol (graphic designer), *THE BURRY MAN*, George Topping and Steven Cannon, *ATTENDANTS*, South Queensferry, Edinburgh, Scotland

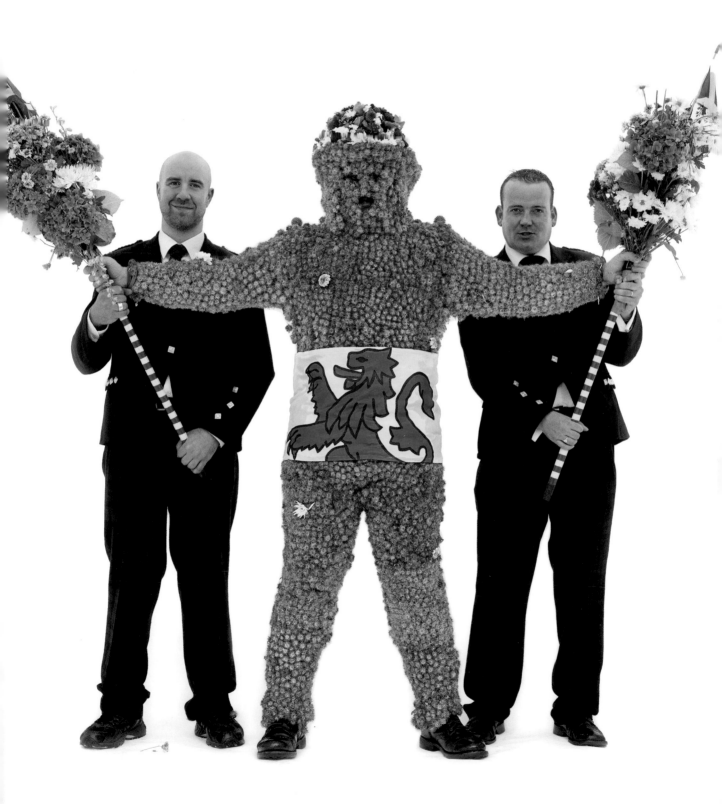

A Calendar of *BRITISH FOLKLORE* Events

DAILY

Ceremony of the Keys, Tower of London, London

SPRING

Dame Elizabeth Marvyn Charity, Ufton Court, Ufton Nervet, Berkshire, Maundy Thursday

Long Rope Skipping, Alciston, East Sussex, Good Friday

Midgley Pace Egg Play, Calder Valley, West Yorkshire, Good Friday

Widow's Bun Ceremony, The Widow's Son public house, Bow, London, Good Friday

Butterworth Charity (distribution of hot-cross buns), St Bartholomew-the-Great, Smithfield, City of London, Good Friday

Uppies and Doonies Football, Workington, Cumbria, Good Friday, the following Tuesday and Saturday

Britannia Coco-nut Dancers, Bacup, Lancashire, Easter Saturday

Maypole Lowering, Barwick-in-Elmet, West Yorkshire, Easter Monday (every three years)

London Harness Horse Parade, Regent's Park, London, Easter Monday

Preston Egg Rolling, Preston, Lancashire, Easter Monday

Biddenden Dole, Biddenden, Kent, Easter Monday

Hocktide, Hungerford, Berkshire, second Tuesday after Easter

Tichborne Dole, Tichborne, Hampshire, 25 March

John Stow and the Quill Pen Ceremony, St Andrew Undershaft, City of London, 5 April

Padstow May Day, Padstow, Cornwall, 1 May

Minehead Hobby Horse, Minehead, Somerset, 1–3 May

Maypole Raising, Barwick-in-Elmet, West Yorkshire, Spring Bank Holiday (every three years)

Jack-in-the-Green, Hastings, East Sussex, Spring Bank Holiday weekend

Knutsford Royal May Day, Knutsford, Cheshire, first Saturday in May

Ickwell May Day, Ickwell, Bedfordshire, Spring Bank Holiday

Helston Furry Dance, Helston, Cornwall, 8 May

Abbotsbury Garland Day, Abbotsbury, Dorset, 13 May

Dunting the Freeholder, Newbiggin by the Sea, Northumberland, third Wednesday in May

Cyclists Memorial Service, Meriden, Warwickshire, Sunday in mid-May

Castleton Garland Day, Castleton, Derbyshire, 29 May, Oak Apple Day

Grovely Rights, Great Wishford, Wiltshire, 29 May, Oak Apple Day

Founder's Day, Royal Hospital, Chelsea, London, 29 May, Oak Apple Day

The Hunting of the Earl of Rone, Combe Martin, Devon, Spring Bank Holiday weekend

Bampton Morris, Bampton, Oxfordshire, Spring Bank Holiday

Headington Quarry Morris, Headington, Oxfordshire, Spring Bank Holiday

Cheese-Rolling, Cooper's Hill, Brockworth, Gloucestershire, Spring Bank Holiday

Cotswold Olimpicks, Dover's Hill, Chipping Campden, Gloucestershire, Friday after Spring Bank Holiday

Scuttlebrook Wake, Chipping Campden, Gloucestershire, Saturday after Spring Bank Holiday

Love Feast, Wicken, Northamptonshire, Ascension Day

Well Dressing, Tissington, Derbyshire, Ascension Day

Beating the Bounds, Tower of London, London, Ascension Day (every three years)

Rush Sunday Service, St Mary Redcliffe, Bristol, Whit Sunday

Bread and Cheese Throwing, St Briavels, Gloucestershire, Whit Sunday

Wessex Folk Festival, Weymouth, Dorset, end May or early June

Thaxted Morris Meeting, Thaxted, Essex, weekend after Spring Bank Holiday

Blessing of the Boats, Whitby, North Yorkshire, June

Appleby Horse Fair, Appleby, Cumbria, early June

Hawick Common Riding, Hawick, Scottish Borders, the first Friday after the first Monday in June

Election of the Mayor of Ock Street, Abingdon, Berkshire, Saturday nearest 19 June

Selkirk Common Riding, Selkirk, Scottish Borders, Friday following second Monday in June

SUMMER

Midsummer Fires, throughout Cornwall starting at Carn Brea, 23 June

Youlgreave Well Dressing, Youlgreave, Derbyshire, week containing 24 June

Tideswell Well Dressing, Tideswell, Derbyshire, Saturday nearest 24 June

Winster Wakes, Winster, Derbyshire, Saturday following Sunday after 24 June

Cakes and Ale Ceremony, Bury St Edmunds, Suffolk, last Thursday in June

Rushbearing, Warcop, Cumbria, 29 June (unless Sunday, then 28 June)

Walking Day, Warrington, Cheshire, Friday nearest 1 July

Horse Fair, Seamer, North Yorkshire, July

Kilburn Feast, Kilburn, North Yorkshire, Sunday after 6 July

Rushbearing, Great Musgrave and Ambleside, Cumbria, first Saturday in July

Vintners' Procession, Upper Thames Street, City of London, second Wednesday in July

John Knill Ceremony, St Ives, Cornwall, 25 July (every five years)

Swan Upping, River Thames, Middlesex, Surrey, Buckinghamshire, Berkshire and Oxfordshire, third week in July

Grand Wardmote of Woodmen of Arden, Meriden, Warwickshire, four days ending on the first Saturday in August

Feast of St Wilfrid, Ripon, North Yorkshire, the Saturday before the first Monday in August

Knighthood of the Old Green, Southampton, Hampshire, third Wednesday in August

Rushbearing, Grasmere, Cumbria, Saturday nearest 5 August

The Burry Man, South Queensferry, Scotland, second Friday in August

Burning Bartle, West Witton, North Yorkshire, Saturday nearest 24 August

Rushbearing, Urswick, Cumbria, Sunday nearest 29 September

St Giles' Fair, Oxford, Oxfordshire, Monday and Tuesday following the first Sunday after 1 September

Abbots Bromley Horn Dance, Abbots Bromley, Staffordshire, Monday following the first Sunday after 4 September

Widecombe Fair, Widecombe-in-the-Moor, Devon, second Tuesday in September

Sheriff's Ride, Lichfield, Staffordshire, Saturday nearest 8 September

Clipping the Church, Painswick, Gloucestershire, Sunday nearest 19 September

Bluecoat School (Christ's Hospital), St Matthew's Day Parade, City of London, 21 September

AUTUMN

Nottingham Goose Fair, Nottingham, Nottinghamshire, last three days of the first week in October

Pearly Kings and Queens Harvest Festival, St Martin-in-the-Fields, London, first Sunday in October

Bellringers' Feast, Twyford, Hampshire, 7 October

Goozey Vair, Tavistock, Devon, second Wednesday in October

Bampton Fair, Bampton, Devon, last Thursday in October

Punkie Night, Hinton St George, Somerset, last Thursday in October

Quit Rents Ceremony, Royal Courts of Justice, Strand, London, late October

Hastings Bonfire Night, Hastings, East Sussex, Saturday nearest 14 October

Antrobus Soulcakers, Antrobus, Cheshire, early to mid-November

Lewes Bonfire, Lewes, East Sussex, 5 November

Hatherleigh Carnival, Hatherleigh, Devon, second Saturday in November

Tar Barrel Rolling, Ottery St Mary, Devon, 5 November

Wroth Silver Ceremony, Knightlow Cross, Warwickshire, 11 November

Firing the Fenny Poppers, Fenny Stratford, Buckinghamshire, 11 November

Lord Mayor's Show, City of London, second Saturday in November

Jury Day, Laxton, Nottinghamshire, last Thursday in November

Tin Can Band, Broughton, Northamptonshire, first Sunday after 12 December

WINTER

Derby Tup, Sheffield area, South Yorkshire, around Christmas

Hoodening, St Nicholas-at-Wade, Kent, around Christmas

Tolling the Devil's Knell, Dewsbury, West Yorkshire, 24 December, Christmas Eve

Bampton Mummers, Bampton, Oxfordshire, 24 December, Christmas Eve

Uttoxeter Guisers, Uttoxeter, Staffordshire, 24 and 25 December, Christmas Eve and Day

Crookham Mummers, Crookham, Hampshire, 26 December, Boxing Day

Flamborough Sword Dance, Flamborough, East Riding of Yorkshire, 26 December, Boxing Day

Greatham Sword Dance, Greatham, Co. Durham, 26 December, Boxing Day

Handsworth Sword Dancers, Woodhouse and Handsworth, South Yorkshire, 26 December, Boxing Day

Grenoside Sword Dancers, Grenoside, South Yorkshire, 26 December, Boxing Day

Monkseaton Morris, Monkseaton, North Tyneside, 26 December, Boxing Day

Marshfield Mummers, Marshfield, Gloucestershire, 26 December, Boxing Day

Ripon Sword Dancers, Ripon, North Yorkshire, 26 December, Boxing Day

Symondsbury Mummers, Symondsbury, Dorset, Christmas and 1 January

Flambeaux Procession, Comrie, Perthshire, Scotland, 31 December, New Year's Eve

Fireball Ceremony, Stonehaven, Grampian, Scotland, 31 December, New Year's Eve

Stragglethorpe Plough Play, Brant Broughton, Lincolnshire, January (date varies)

Wassailing, Combe in Teignhead, Devon, January (date varies)

Mummers' Day or 'Darking Day', Padstow, Cornwall, 1 January

Haxey Hood Game, Haxey, Lincolnshire, 6 January, Twelfth Night

Bodmin Wassailers, Bodmin, Cornwall, 6 January, Twelfth Night

Twelfth Night Revels, Bankside, London, 6 January, Twelfth Night

Baddeley Cake, Drury Lane Theatre, London, 6 January, Twelfth Night

Whittlesea Straw Bear Festival, Whittlesey, Cambridgeshire, Saturday following Plough Monday (first Monday after Twelfth Night)

Apple Wassail, Whimple, Devon, 17 January, Old Twelfth Night

Wassailing, Carhampton, Somerset, 17 January, Old Twelfth Night

Cradle Rocking, Blidworth, Nottinghamshire, Sunday nearest 2 February

Clowns Service, Holy Trinity Church, Dalston, London, first Sunday in February

Red Feather Day, service in commemoration of Sir John Cass, St Botolph-without-Aldgate, City of London, Friday nearest 20 February

Westminster Greaze, Westminster School, London, Shrove Tuesday

Ball Game, Sedgefield, Co. Durham, Shrove Tuesday

Football Match, Alnwick, Northumberland, Shrove Tuesday

Football Match, Atherstone, Warwickshire, Shrove Tuesday

Hurling the Silver Ball, St Columb Major, Cornwall, Shrove Tuesday

Royal Shrovetide Football Match, Ashbourne, Derbyshire, Shrove Tuesday and Ash Wednesday

Cakes and Ale Ceremony, Stationers' Hall, City of London, Ash Wednesday

Acknowledgments

Many people have been involved in the project and book and I would like to thank the following particularly for their contributions: Simon Costin, director of the Museum of British Folklore, for all his knowledge, help and encouragement, both with the photographic project and for contributing the book's introduction (the Museum of British Folklore is a registered charity and more information about the museum can be found at www.museumofbritishfolklore.com); Robin Muir, for his foreword and his enthusiasm right from the start of the project in 2009; Toby Anstruther, Dimitri Ramazankhani, Kensington Rea Leverne and Rowan Spray for their photographic assistance; and Thames & Hudson for their support.

I am extremely grateful to the wonderful sitters and I apologize to anyone who inadvertently may have been wrongly credited or did not make the final edit; there were just so many images, which made the choice difficult. The project would also not have been possible without the assistance of the various folklore societies, as well as The Crown public house in Bacup, Lancashire, the East Hastings Angling Club and the Wimbledon Village Fair, that let us set up.

For their help, knowledge and advice along the way, I am indebted to Terry Bailey, Neville Earnshaw, Ben Jones, Linda Krawecke, Keith Leech, John Nichol, Mellany Robinson, Doc Rowe and Pete Williams. Celestia Anstruther contributed a valuable philosophical critique. Last but not least, my thanks go to my wife, Harriet Anstruther, for her unflinching encouragement and support, which made the whole project possible.

OLD GLORY MOLLY, *Whittlesea Straw Bear Festival*, Whittlesey, Cambridgeshire